CITIZEN
KEANE

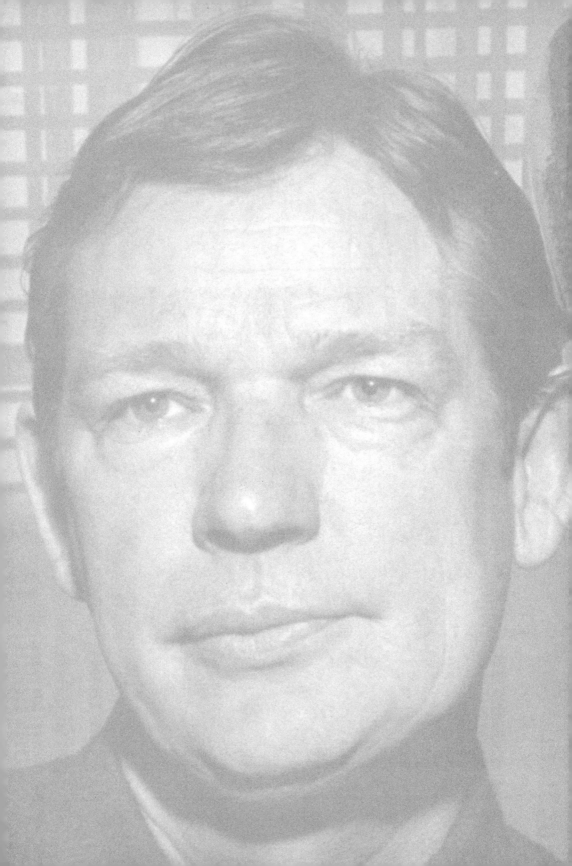

CITIZEN *KEANE*

THE BIG LIES BEHIND THE BIG EYES

ADAM PARFREY
AND
CLETUS NELSON

fh

ACKNOWLEDGMENTS

Adam Parfrey wishes to acknowledge the participation of both Walter and Margaret Keane, in addition the assistance of Judith Moore, Jim Holman, Mary Lang, Abe Opincar, Scott Lindgren, Christopher Cooper and Danna Voth for their company and help during the creation of the original *San Diego Reader* cover story. More recently, Elizabeth Perikli suggested this book's subtitle, and Long Gone John Mermis spoke at length with me regarding his promotion and collection of Margaret's work. Carrie Schaff, Frank Kozik, Philip Smith, and Paul Mavrides helped with the images seen within. Thanks are also due to Bess Lovejoy for her careful reading and suggestions. And a big tip of the hat to co-author Cletus Nelson for digging out many intriguing revelations.

Cletus Nelson wishes to thank the following individuals who lent a helping hand or a sympathetic ear when needed most: Dick Boyd, Ann Bradley, Sam Gaines, Annette Kesterson, Michael S. Moore, Ann Miller, Bob Miller, Tanya Verigin, and Janet Whitchurch.

TABLE OF CONTENTS

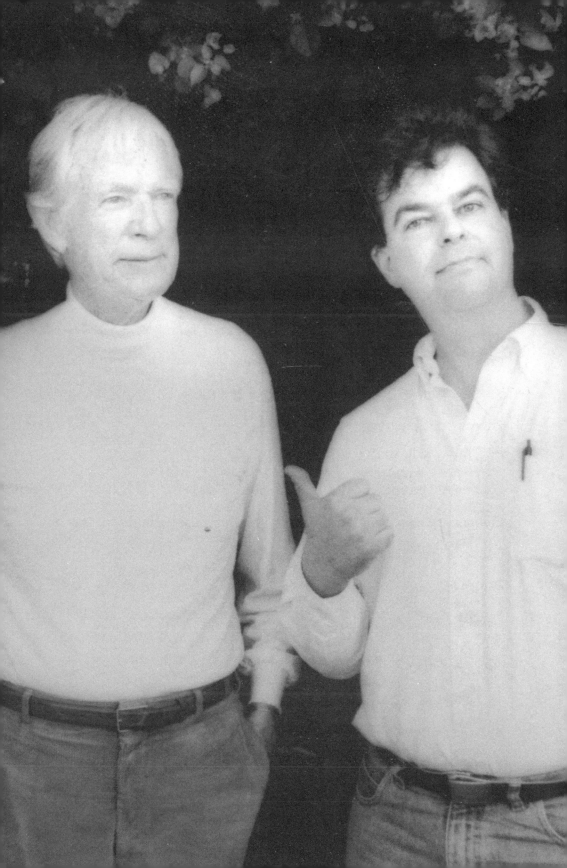

PREFACE

Adam Parfrey

Much of the material for this book came from a cover story I had written for the *San Diego Reader*, that city's weekly newspaper that published a good number of my feature articles in addition to a column called "HelL.A." that called out my love/hate for my hometown, Los Angeles.

On a 1991 trip to San Diego to finish research for another article—in those dark pre-Google days, one discovered stories by actually talking to people and keeping one's eyes open in the physical world—I ran across an article in a regional throwaway about Walter Keane. Yes, Keane. Walter Keane. The supposed progenitor of garish Big Eye art was alive and living in La Jolla, where he was promoting a self-published memoir that presented himself as an artist on the level of Michelangelo, and stunningly a victim to court verdicts, fraudulent journalists, and a vindictive, sex-mad ex-wife.

Walter Keane and Adam Parfrey. Photo by Scott Lindgren.

Yes, here was a good story.

On the phone, 80-year-old Keane tried to make friends with me in dirty old man style. We hardly spoke for five minutes before he asked whether I had a girlfriend. Then he urged me to describe her looks, and then the frequency of our lovemaking. Before I was able to change the subject, he asked, "She doesn't complain about sucking you off, does she?" "That can be a real problem if she's not willing and eager. I had the best, and can give you tips."

What an odd bird, I thought, as Walter and I made plans to get together for an interview, but first I made my way to a courthouse office building where I got dozens of pages of court documents Xeroxed. The originals are no longer available from court archives, but some of the juicier excerpts are repeated in this book.

At home I searched out a prized possession: a two-volume monograph of Keane art, one titled *Walter Keane*, the other *Margaret Keane*, both with cellophane overlays above the precious tipped-in color plates. Both volumes were also boxed into a slipcase, mimicking ostentatious high-end art books. What a strange production this was, as it included the musings of some stuffy elitist WASP with three names. My girlfriend, who was a talented artist herself, told me how much she liked Margaret's paintings of depressed Modigliani-like young women. I had to agree despite society's dismissal of Keane art as being the worst sort of sentimental claptrap.

The more I met with Walter Keane, the stranger came the story. The manipulations were extravagant, and no former friend or ally would ever back up his claims. When I dug into all his various court cases against Margaret, Walter came forward with salacious and horrifying

accusations about the sexual behavior of his ex-wife, a woman deeply committed to the Jehovah's Witness faith.

I felt a bit sleazy when I read Walter's accusations about Margaret in a phone interview. Luckily for me, she reacted well enough to all this, and chuckled. "Yes, that's the way he is," she remarked before we spoke at length about her trials and tribulations. A few weeks later I received from Margaret a couple of Jehovah's Witness books with pleasant inscriptions inside.

At the time I was writing this story, wild, figurative "lowbrow" art started to get a lot of attention, both in Los Angeles art galleries like La Luz de Jesus when it occupied the second floor of a building on Melrose Avenue, and the influential "Helter Skelter" exhibition at the L.A. Museum of Contemporary Art that featured, among others, the paintings of Robert Williams. Williams also became the father figure for a new magazine, *Juxtapoz*, that promoted this new figurative art universe, damning those who rebuked its imaginative creations as "kitsch" or "illustration." Not that Robt Wms loved Big Eye art, but the idea of hanging kitsch seemed cool once again, and collectors came out of the woodwork to purchase inexpensive Big Eye art iterations to hang in hip coffeehouses, diners, hairdressing studios, and nightclubs. The creepier the kitsch factor, the better for the walls.

All of which begs the question: what is "kitsch" exactly? Is it the cheap mass-produced stuff one could have found in a Blue Chip stamp catalogue? Or is it the high-cost but intentionally lowbrow work of mutual funds broker turned artist Jeff Koons who sells massive balloon dogs for tens of millions of dollars? What makes one worthless and the other immensely valuable?

The remarkable Norwegian painter Odd Nerdrum wrote a book about the kitsch conundrum called, naturally, *Kitsch: More Than Art*. Nerdrum's book wishes to resuscitate the word "kitsch" from the insult applied to artwork that offends the modernist or post-modernist sensibility. After hearing his beautiful oil paintings belittled with the "K" word, Nerdrum made it his life goal to elevate kitsch from being an insult to a badge of honor.

Without stating it overtly, Nerdrum's *Kitsch* book pays homage to Keane art and his/her particular aesthetic:

> *Modernism itself has become a tradition that has conquered the entire Western world. Institutions, critics, artists and educated people are obliged to be "open for the new"... My concern is what Modernism has pushed out as its 'other' in the same way that Christianity demonized its competitors, so too did Modernism, and the rule of Modernism's Hell was christened "Kitsch"— signifying the antithesis of modern art. Kitsch became the unified concept for all that was not intellectual and new, all that was conceived as brown, old-fashioned, sentimental, melodramatic and pathetic. As the Austrian author and philosopher Herman Broch put it in the 1930s: "Kitsch is the Anti-Christ, stagnation and death."*

> *We all know the gypsy girl and the little boy with a tear, the grandmother with a child on her lap and the fisherman with his pipe, the two silhouettes against a sunset, and not the least, the moose by the lake. All of this became a forbidden*

*area for the tastes of the educated. The so-called
"simple" and "blind" taste for this imagery stood
in contrast to Marx, Freud and the entire Modern
elite who had been seeing through everything
down to is smallest particle.*

Modernism must have died a bit when Walter Keane turned his marketing talents from selling real estate to mass-produced postcards, posters and lithographs of weepy waifs, when he moved art from its gallery-based confines to telephone poles, tourist shops, and other populist marketplaces. Even Andy Warhol paid tribute. It didn't matter much whether critics hated the work and lampooned it as "kitsch" and "sentimental trash" if Joan Crawford, Natalie Wood, Kim Novak, Jerry Lewis and Red Skelton would show theirs off with pride of ownership to syndicated newspapers and magazines.

It required effort for Walter to party and pretend to care about hungry children with celebrities, businessmen and hot young ones while introspective Margaret labored with a paintbrush at home.

In his last days occupying a small cabin in La Jolla, Walter Keane could only reflect on how his behavior and claims drove away Margaret, his magic paycheck, to Hawaii, and complain of a sore arm when people asked him why he no longer painted his own Big Eye art as displayed in those fancy art books.

After the cover story appeared, Walter wrote an angry letter to the *San Diego Reader* accusing me of accepting six-figure largesse from Jehovah's Witness headquarters to play up Margaret as the true Big Eye artist. If only.

Suburbia's Favorite Artist

1965 was a year of bug-eyed glory for the former real estate salesman Walter Stanley Keane. With drunken glee, Keane appeared at snooty galleries, universities, and museums, reproducing the kitschy images bearing his name on cheap postcards, greeting cards, and lithographs that found their way to walls and refrigerators in cities and suburbs, both big and small. Keane banked big money while daily papers showed him hanging out with movie stars and famous pop singers. Even Andy Warhol paid homage to the Keane kids phenomenon.

Keane bragged to reporters that he "romped through life with the evident enjoyment of a terrier rolling in a clover patch."[1] He wasn't exaggerating. This North Beach artist may well have been the most popular painter in the country and Keane art was seemingly everywhere—from the sales bins at Woolworths to the gilded mansions of Hollywood royalty. As his income surged comfortably into seven figures, Keane decided he would keep things simple. "All that really matters to me," he explained to an admiring *Life* magazine reporter, "is painting, drinking (which, the way I look at it, includes eating), and loving."[2] It seemed like the party was just getting started.

Keane's fortune was made from a style stunning in its simplicity. Weeping waifs. Tearful children. All bearing hypnotic, saucer-sized

orbs. It was said that if you looked at them long enough, the distressed children seemed to stare at you, even if you moved about the room. The paintings didn't just tug at your emotions—the sad children possessed the subtlety of a jackhammer.

"Let's face it," he boasted to *Life* magazine, "Nobody painted eyes like El Greco, and nobody can paint eyes like Walter Keane."[3] More discriminating art enthusiasts, critics, and academics didn't quite agree, finding the paintings formulaic and sickening in their sentimentality. But the dissenters were a minority. The rest of America fell in love with Keane's Big Eyes and made him a household name.

As the Big Eyes grew in popularity throughout the 1960s, dozens of imitators moved to cash in on the Keane style and Big Eye prints sprouted like toadstools: "Gig" painted mooney-eyed mongrels and alley cats; "Eden" did corkboard prints of Keane-like waifs dressed as moppets in tattered clothing; "Eve" transformed Keane-like kids into precocious go-go dancers. Even black velvet iterations of Big Eye kitsch followed in their footsteps.

New York still remains the center of the gilded aesthetic universe. Any desire to break into the art world necessitated the artist to influence important gallery owners who in turn impressed the press and museums. If you were considered the exclusive taste of the day, this was in part due to a sense of your exclusivity. To seem "new," somewhat challenging, but not entirely different, more like a quotation on recent art history. That's the way the game was played.

Walter Keane was quite the operator, a true American type. A "naïf" who seemed to buy into his own sales pitch. We'll discover later that Keane had hired Tom Wolfe, who used the pseudonym "Eric Schneider," to write an over-the-top satire that portrayed both Walter and Margaret Keane's Big Eye kitsch as furthering the work of great masters deserving of great accolades. Keane's self-inflation later

permeated his own autobiography, *The World of Keane*, in which he felt the need to tell readers that in his dreams his grandmother called him a "great master" until he came to understand that, yes, he was deserving of this title.

The gratuitous sentimentality of weepy waifs combined with Keane's claims of eternal artistic genius make for a particularly American type of salesmanship. Yet Walter Keane's insistence that he was a rare artistic genius has a desperate quality to it in light of the lawsuits he lost to Margaret Keane concerning the real originator of the Big Eye style. As we shall discover, the true artist of the weepy waifs, Margaret, became a victim of her scoundrel husband, and her despair seemed to actualize in her art in ways the copycat competition utterly failed to achieve.

Keane wondered, why sell just a handful of paintings to a few well-heeled collectors? That's not how real estate moved in new suburban tracts or how TV dinners were sold in supermarkets. Keane thought, why not eliminate the middleman, open a gallery and sell directly to the public? It wasn't easy at first. "I never intended to become an artist in the garret existence," Keane remembered, "but there were lean years when we started."[4] Paintings went for as little as $20 and when money was tight, a picture or sketch was bartered to help pay the bills. "We just about furnished our house by trading canvases for furniture," Keane later recalled.[5]

Selling paintings was hard work in the early '60s, and Keane's art enterprise took a few years to get off the ground. Handbills were made, paintings were shown at community art festivals, and some of the earlier works were even hung in a local nightclub. Fortunately for him, Walter had an innate gift for the sort of blather that played well with newspapers, magazines, and nightly news programs. Articles about the Keane Gallery began to appear in various Bay Area publications— *Oakland Tribune*, *San Francisco Call Bulletin*, *Hayward Daily Review*, and others. Soon enough, reporters from the major national papers

were running profiles of the larger-than-life North Beach artist who painted weeping, saucer-eyed children.

Hardly a week passed without Walter Keane devising a way to get his name and photograph into the newspapers. All he'd have to do was call an old "school chum" at United Press International, and a photographer would hurry to Keane's home to snap a few pictures of Walter posing in front of a half-completed canvas. Keane had also snagged guest spots on a few television shows like the *Jack Paar Show*, which helped him gain a few influential celebrity admirers and a direct pipeline into millions of American living rooms. He understood the power of the medium. "We've used television more than any other way of getting ourselves known," Walter explained, "It's beautiful how many people can be exposed to your work through, say, just one TV show."[6]

Walter Keane wasn't your typical brooding artist and, like all good salesmen, he knew how to connect with Cold War conservatives. He may have been entering middle age, but he looked at least a decade younger (he wasn't always truthful about his age). He wore his windswept light brown hair short, and favored monogrammed shirts. If you saw him on the street, it wouldn't be hard to mistake him for an insurance salesman on his day off. And Keane had a certain genius when it came to making friends and cultivating business connections.

"We don't need New York anymore," he once said, "our real strength, anyway, is in the interior, in places like Boise. What a reception they gave us when we went to Boise!"[7] If millionaires could buy quality art, why couldn't kindergarten teachers, housewives, or forklift operators? So Keane mass-marketed waif images like so many coffee mugs. If some art critics called it crass commercialism, he wasn't going to let them spoil the party. He sold lithographs, miniatures, collectible plates, greeting cards, and wall posters. Big Eye "Little Miss No-Name" dolls were mass-marketed, and the only reason they didn't bear the magic Keane name is that the toy company Hasbro didn't

4

offer Walter enough money. Walter later claimed that he did not lend out his name for the doll because he was an incorruptible great artist.

While Keane originals went for anywhere between $25,000 and $50,000 during the peak years, unframed lithographs were available for $3.50 to $25.00 for a first edition print. In 1964, Keane grossed $2,000,000 from prints alone.[8] This was popular art in the truest sense of the word, and Walter didn't just think of himself as an artist. He was introducing millions of people to fine art. "I've helped the art world just as Picasso and Modigliani have," he once bragged. "I've made more people aware of paintings, which makes them buy more, just like they go buy more records and books once they're exposed."[9]

So why were so many Americans enthralled by Keane paintings? America was a nation in transition when Big Eye art appeared. The GIs were home from the war, the economy was booming, and the country was awash in consumer goods. Disposable incomes were rising and thousands of new homes were going up as an exodus of families spilled out of the nation's major cities. The home with the well-manicured lawn and the two-car garage had become the centerpiece of the American dream. By 1960, one-third of the population lived in the suburbs—that's a lot of living room walls.

If Americans were prosperous, that doesn't mean they were altogether content. The early Cold War years often bring up fond memories of tail-fin cars, crew cuts, and martini shakers, but it was also a time of great unease. The public was constantly being reminded that a full-scale nuclear war with the Soviets was a distinct possibility. Alongside the fallout shelters and duck-and-cover drills, propaganda films explained how to survive a nuclear attack. Books like *The Organization Man*, *The Lonely Crowd*, and *The Man in the Gray Flannel Suit* explored a growing sense of societal unease.

The U.S. may have been enjoying a remarkable stretch of prosperity but the world had also become more dangerous and unsettling. The melancholy waifs triggered an instant emotional reaction—and

can any art that provokes an emotional reaction be called bad? "They drew you in," says Bob Miller, a collector and longtime Keane friend. "There was just a certain magnetism about the paintings."

Keane also maintained that the paintings' children offered an underlying political message. "If mankind would look deep into the soul of the very young," he once said, "he wouldn't need a road map."[10] If Walter's outspoken concern for the world's children seems relatively commonplace today, it was uncommon in the early 1960s. The United Nations General Assembly had only recently enacted the Declaration of the Rights of the Child in 1959, and child abuse, once considered a taboo subject, had entered the national conversation with the 1962 *Journal of the American Medical Association* article "The Battered Child Syndrome."

This was an opportune moment to speak on behalf of the young, and it wouldn't be long before baby boomers would rebel and corporations focused their efforts on selling to kids and older folks who wanted to avoid the sudden disdain for aging. Both parents and children alike saw in the waifs a wistful symbol of lost innocence—or possibly hope.

Though Keane thought he had a powerful message, he was treated like he was a joke. As far as the art establishment was concerned, the millions of Keane fans only seemed to reinforce the image of America as a cultural backwater despite the heralded rise of Abstract Expressionist artists like Pollock, Rothko, and de Kooning.

The New York School artists were renowned for their brooding self-absorption. They weren't just making art—they exposed their raw, naked, tortured souls. Many of them dabbled in Jungian psychology, adopting an air of humorless self-importance. At the time Walter and his wife began selling paintings, the Pop Art movement was rapidly displacing the Action painters. The irreverent Pop artists brought a lively sense of mockery to the creative process. It could be argued that the mass-produced Keane paintings were Pop Art in the truest sense of

the world. Satirically or not, Andy Warhol praised Big Eye paintings just for being popular.

Walter Keane wasn't worried in the least what critics thought. A look at the sizeable sum in his bank book provided him with the last laugh. Furthermore, Keane paintings appeared in art museums in Spain and Belgium, and despite hate from a *New York Times* critic, the United Nations itself purchased and hung a Big Eye painting, as did Madame Chiang Kai-Shek. The list of celebrity owners of Keane paintings was growing with each passing day. Natalie Wood, Red Skelton, Joan Crawford, Dean Martin, Jerry Lewis, Eve Arden, Kim Novak—all became proud owners of dearly priced Keane oils. All in all, it was a charmed life for a starstruck native of Lincoln, Nebraska. Even politicos like George Christopher, who served as the last Republican mayor of San Francisco from 1956 to 1964, paid Margaret Keane $4,500 (a fairly large amount at the time) to paint his portrait. According to the *Modesto Bee* in December 1959, Margaret also painted high priced portraits of members of the super-rich DuPont family as well.

This being the golden age of the cocktail, the three-martini lunch, and the living room tiki bar, Walter Keane was in his gassed-up element. Fifty years ago, alcoholism wasn't considered a disease like it is today. If you were drinking too much, it just meant that you needed to go on the wagon for a while. Most social activities revolved around a few shared drinks. Once he became a celebrity, Walter's carousing grew legendary. "He was just always a lot of fun to be around," Bob Miller remembers. "Wherever Walter went, his persona was like a magnet."

As Keane later recalled his rock star lifestyle:

"I knew all the big shots. Dali, Picasso, they were all my friends. One time in Paris, Picasso was throwing a big party and I was there. I took a canvas and put it up on an easel and I laid down ten hundred-dollar bills. I said, 'Master, that's for you and your girlfriends. All I want you to do is X, Y, and Z on there and write 'Picasso.' He

thought I was making fun of him. Joan Crawford, she introduced me to one of my first great loves, Miss Chivas Regal. And she threw parties for me, introduced all the Hollywood stars to my work. I had this long bar in my Woodside home, it came around the horn, Red Skelton tried to buy it for four thousand bucks once. Seventeen people could sit around my bar room. The Beach Boys, Maurice Chevalier were guests there. Howard Keel and all those guys. We'd have parties until four in the morning. Dinner, drinks, anything they wanted. Always three or four people swimming nude in the pool. Everybody was screwing everybody. Sometimes I'd be going to bed and there'd be three girls in the bed. I took a photo once of three of the girls there. Crazy, wild..." [11]

When he wasn't trading drinks with Hollywood royalty, going to parties, or boozing it up in some exotic locale, Keane could be seen knocking back a Chivas on the rocks at one of his favorite North Beach nightspots or tooling around San Francisco in a gleaming white Cadillac convertible with a telephone installed in the front seat (a rarity at that time). And the money kept rolling in.

Meanwhile, lurking in the background, and painting Keanes in a basement studio, was Walter's long-suffering wife Margaret. While Walter hit the bars and kept the reporters busy, Mrs. Keane was trying to start a new life in Hawaii. In 1965, Margaret filed for a legal separation after a decade of fulfilling the role of being Walter's wife. She later claimed that Walter was simply impossible to live with. He constantly criticized her, stayed out late drinking, and at times could be a jealous man. Once a judge approved their legal separation, they each started new lives, telling the press that they'd forever remain friends and business partners.

A Southern blonde with a gentle voice and a slender figure, Walter's ex is an accomplished portraitist, her paintings of winsome adolescent women, painted in a style akin to Modigliani, having earned her a certain degree of fame alongside Walter's nationwide notoriety.

8

Yet during and even some years after her marriage to Walter, Margaret remained the Big Eye artist's shadow woman, a mere portraitist who could never quite compete with her husband's waifs. Near the end of their marriage, Walter produced a two-volume vanity monograph under the imprint *Tomorrow's Masters Series*. Printed in Japan, editions were published simultaneously in English, French, Spanish, and Japanese. One of the two volumes is devoted to Walter's waifs, complete with posed shots of Walter holding five paintbrushes as he daubs a reflective highlight on a saucer eye. Margaret's companion edition is devoted solely to her mysterious, long-necked, almond-eyed women.

Keane was never shy about expressing open admiration for his wife's talent. He'd called her the country's finest woman artist. In the various media profiles of her husband, Margaret was usually depicted as the perfect wife: raising their two daughters, running the household, and painting in her spare time. If Walter was a gregarious, talkative extrovert, Margaret (who was 12 years his junior) was his opposite— polite, shy, withdrawn, and given to pondering spiritual matters. Walter's soon-to-be-ex-wife also harbored a well-kept secret that in a few short years would effectively destroy Walter's well-crafted persona.

In the mid-1960s, at the height of Walter's fame, Margaret was the only one who knew that he had perpetrated a humbug of monumental proportion. The man wasn't a painter at all. Margaret was the creator of all the Big Eye art. Walter basked in the glory, partied with the celebrities and reaped the rewards. As she would later relate, the tearful, doe-eyed children she painted had nothing to do with Walter's supposed belief in children redeeming the world. The weeping waifs reflected her own sorrow.

Margaret played a part in Walter's deception for over a decade but after moving to Hawaii, remarrying, and getting her life back in order, she decided to end the charade once and for all. It wouldn't be a clean break. Walter wouldn't go away quietly. He denied her claims for years

9

and it would take an ugly legal battle to finally settle the matter of who painted the popular Big Eye waifs. Margaret would finally emerge from the ordeal relatively unscathed while she gained a new generation of fans.

Keane would later remarry and try to regain his former celebrity, but people didn't have much time for a man who had stolen his wife's art. As the years passed, his drinking only got worse and he was never able to reclaim his former fame. He would later complain that a nagging shoulder injury prevented him from painting and would spend the better part of his twilight years writing and rewriting a strange memoir he called *The Real Love of Walter Keane*.

Although he finally walked away from his lifelong booze habit and reveled in his newfound sobriety, the years of hard living had taken their toll. By the time his self-congratulatory autobiography was made available in the early 1990s, he was already yesterday's news and few took notice. And his life was beginning to wind down. When he finally succumbed to lung and kidney disease at the age of 85 on December 27, 2000, there were few A-list celebrities at his bedside.

Up to the bitter end, Keane hoped he'd be remembered as the creator of simple, well-crafted mass-market paintings of doe-eyed weeping children. "I guess if I'm after anything," he once said, "it's to be remembered as one of the *good* bad ones."[12] It was a pretty humble aspiration for a man of Keane's outsized ego. Of course he didn't get his wish. Defrocked as an artist and scorned by a once-adoring public, his passing barely merited a mention in the newspapers.

The *San Francisco Chronicle*, which had once given ample column space to Keane's rise to fame and subsequent fall from grace, was one of the few major papers to note his passing. "Artist Associated with Big Eye Portraits" was the headline that appeared above his obituary. *Chronicle* reporter Dan Levy charitably described Keane as a "flamboyant 1950s and '60s North Beach artist" but was careful in remarking that his wife Margaret was the artist behind the legendary Big

10

Eye paintings. Recounting his failed legal battle with Margaret, Levy noted that, "until the end," Keane "insisted he was the creator of the big-eyed children." [13]

It's safe to say history has rendered its verdict and Walter will likely be remembered as a cunning opportunist who reaped millions posing as a painter. Nevertheless, even if he went to the grave vowing that he was the victim of an international ring of art forgers, a devout religious organization and a spiteful ex-wife, the story of Big Eye art cannot be told without Walter enjoying a starring role. His motives were largely self-serving but his detractors (Margaret included) will agree that his P.T. Barnum-like salesmanship and genius for self-promotion were instrumental in putting Big Eye art on the map.

If Walter's life was never the same once his artistic credentials were called into question, Margaret's had a smoother ride. She has continued to produce her trademark Big Eye paintings and seen renewed interest in her work. Although Keane art enjoyed a brief resurgence in the 1970s, it wasn't until the late 1980s that it again became a full-blown cultural phenomenon. Retracing her own journey from the fringes of the San Francisco art scene to the mainstream, Keane art reemerged as a counterculture phenomenon.

As the retrospective gathered momentum, Keane-inspired images began appearing in 'zines, underground comics, high fashion, cartoons, and graphic design. A new Keane Gallery opened in San Francisco and dozens of fan sites and modern-day Big Eye painters have paid tribute to her unique painting style. A Hollywood biopic involving longtime Keane fan Tim Burton was made in 2013, and the ensuing interest generated by the film will only serve to further burnish her reputation and attract millions of new Big Eye enthusiasts.

Margaret Keane's waifs have outlived and outlasted the critics who derided her work, and her paintings have earned their own unique place in American culture. Wayne Hemingway, who included chapters on Big Eye art in his *Just Above the Mantelpiece: Mass-Market Masterpieces*

(Booth-Clibborn Editions, 2000) is fascinated by the strange trajectory that Margaret's work has taken. "The Keane story serves as a parable of late twentieth-century culture," he writes, "Bohemian artists decide to make money by becoming mass-market, consequently becoming shunned by bohemian society, only to find that over a thirty-year period media coverage of bohemian culture turns it into mass-market art again!"[14]

It's a strange and improbable tale that has long needed to be told. The first seeds for this book were planted over twenty years ago when Adam Parfrey published "Citizen Keane" in the *San Diego Reader*, which examined, among other things, the contentious legal battle between the Keanes. It was one of the last profiles of Keane before his death. The article also appeared in *Juxtapoz* magaine as well as Parfrey's *Cult Rapture* anthology (Feral House, 1995).

Whatever your opinion of Big Eye art, the story behind it has all the ingredients of a page-turning novel—love, fame, celebrity, betrayal, deceit, substance abuse, courtroom drama, and even a religious conversion. In the pages that follow, we'll unearth the origins of two remarkable individuals and chronicle the trajectory of Keane art from its origins in beatnik-era San Francisco to nationwide acclaim. As Walter himself once said, "What we've done can never happen again."[15]

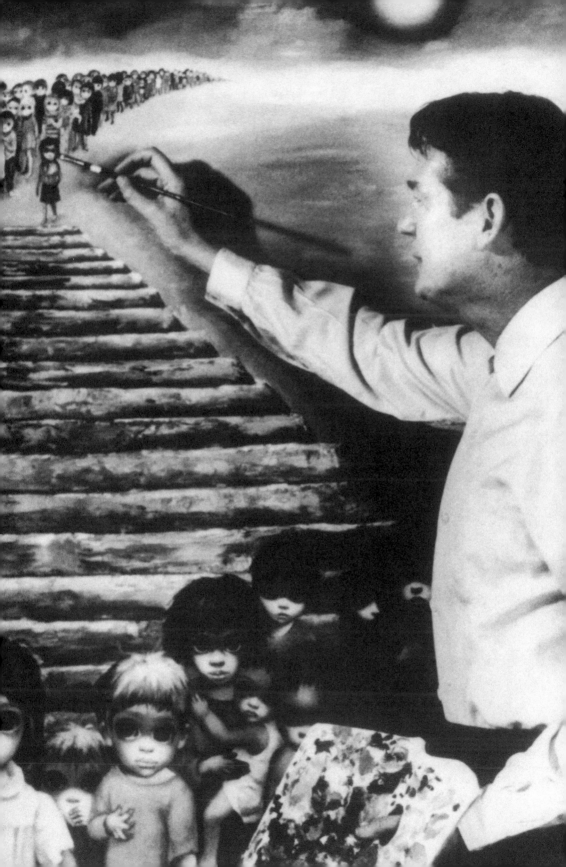

Gray Flannel Suit:
The Reinvented Walter Keane

When Walter Keane made the fateful decision to pose as the artist behind his wife's Big Eye paintings, it didn't mean his creative energies went into hibernation. Like every good salesman, Keane understood that sometimes the best way to move a product is to tell a good story. So he devised an oddly compelling artist biography for himself that may have been his finest creation. Up until Margaret revealed his lies, Walter's account of his transformation from staid businessman to jet-setting celebrity artist never failed to charm credulous reporters and an admiring public.

As Walter warmed to his new role as a spokesman for the world's starving children, his previous career receded further into the background. Although he played a lead part in dozens of interviews and newspaper profiles, rarely did he ever speak in detail about his early life, and always began his story with his his midlife crisis. The way Walter liked to tell it, he was once a card-carrying member of the establishment, an overworked business executive with a painful ulcer "the size of a watermelon." The ulcer, he'd explain, was from a "frustrated urge to paint."[16] Then one day, the unhappy realtor decided to drop out of the rat race, study painting, and devote his life to art.

Success soon followed.

If Keane's impressive story wasn't altogether true—especially the parts that involved him actually picking up a paintbrush—it also wasn't entirely false. Like all good storytellers or liars, he mixed nuggets of truth with embellishments and fabrications, but no one seemed to notice the difference. Margaret was often Keane's best ally, as she would go on record praising his talents or nodding in agreement as he told of his development as an artist. Yet at times he couldn't keep his lies straight. Minor details (like his age or the year he met Margaret) changed with each telling. But so long as Keane's story made good copy, no one seemed interested in doing any fact-checking.

A (newly sober) Keane spent his later years giving his success story one final dramatic retelling in his vanity-published tell-all, the lurid and often fantastic *The World of Keane* (Creative Books, 1983). The title, which appeared in very few bookstores in the early 1990s, mixed sexual braggadocio, mystical communications with the dead, monumental self-pity about the torments of the artist, and delusional patches of self-inflation, culminating in a bizarre scene where Michelangelo elects Walter Keane to the "Elysian Gallery of Artistic Immortals."

His autobiography begins in rural Nebraska during Walter's childhood as he ("the eleventh child from the top") vies for parental attention among thirteen other siblings. An art-loving grandmother is fondly remembered as she instructs Walter at the age of five on how to paint a rose. Inexplicably, the narrative suddenly skips thirty years— barely a mention of Walter's schooling or ten-year career in real estate speculation, other than his epiphany away from the world of business signaled by the onset of crippling stomach pain and a momentous encounter with a flock of birds:

> *As I listened to the birds sing, staring fixed-*
> *eyed and watching them fly freely away, I lifted*

my arms toward them and cried out, "Please wait;
I am one of you!" I closed my eyes. Then came the
spark. My dazed, feverish request was answered.
I realized that my innate artistic talent had been
locked in my brain and my body for all these years.
Feeling a sudden strength and conviction, I knew
that a new life had begun.[17]

Walter flies like a bird to Paris in 1946 with his first wife Barbara, who soon returns to the familiar comforts of California, leaving Walter to pursue a bohemian life of drinking, loving, and painting. On a significant side trip to Berlin Walter discovers the sight of "frightened, neglected, and often abused children."

Nothing in my life until then, or since, has **17**
ever made such an impact as the sight of those chil-
dren fighting over garbage. As if goaded by a kind
of frantic despair, I sketched these dirty, ragged
little victims of war with their bruised, lacerated
minds and bodies, their matted hair and runny
noses. Here my life as a painter began in earnest;
Paris had been only a lighthearted apprenticeship.
The insane, inhuman cruelty inflicted upon these
children cut deeply into my being. From that mo-
ment on, I painted the lost children with the eyes
that forever retained their haunting and haunted
quality.[18]

Walter returns to Paris with a "single-minded" resolve to alert the world to the plight of these pitiful German war orphans. If it was a time of "sleepless nights, waif-filled dreams and depression," distraction comes in the form of a prostitute-with-a-heart-of-gold named Colette

and her gamine daughter, Renee. Colette ("perfect part for Cher," Keane observed in 1991) lives an idyllic life with Walter, procuring little girl models for him in her spare time. On a trip back to California in the summer of 1947, Walter is chagrined to find that his wife he cheated on does not welcome him back with sufficient ardor, and so he repairs to a houseboat in Sausalito to live in bohemian rhapsody: wine, women, and song. In a moment of unguarded self-reflection Walter reveals, "I am probably the only man alive who washes his hands before unzipping his pants and then washes them again after zipping up."[19]

In between perfecting his trademark waifs, he has a child, Susan Hale, by the ordinarily unresponsive Barbara in December 1948. The family sets sail for Paris, and Walter sets up a study in Montmartre. As his marriage to Barbara further frays, Walter sojourns to Hong Kong, taking up with yet another prostitute-with-a-heart-of-gold named Mai Ling ("Her body moved with the rhythm of a French ballerina," Keane remarked), whom he sets up in business.

The rambling man sets sail once again and is saved by a lithe young thing named Dana in a life-threatening shipwreck ("Placing her body close to mine to keep warm..."). When the two are pulled from the water by a homeward-bound Japanese fishing boat, Walter goes on to savor the delights of postwar Japan, and from there flies to Tahiti, where he spends his time painting waifs while comparing himself to Gauguin. As he eyes the Tahitian beauties, he admits that "I needed a woman in my bed," but remembers the "great master who died of syphilis from girls such as these" and wisely abstains.[20]

Back with his Colette in Paris, Walter decides to keep her occupied as his art dealer. Accompanying Walter on a business trip to Tokyo, Colette hears that her young daughter Renee has been run over by a car while fleeing a rapist. Walter flies back to Paris with the traumatized Colette and discovers Renee's diary. Three pages of Walter's autobiography are taken up with gruesome details from this diary, though he admits having no real knowledge of the French language.

Wednesday: Jacques picked me up at school a few minutes early. As soon as we walked into the apartment he removed all his clothes. He drew a hot bath for the two of us and asked me to wash his back. I laughed and told him Mama did Walter's. When we got out of the tub, Jacques asked me if I would kiss his hard penis. I said, "No." He took my hand and with violence in his voice demanded I hold it and kiss it or he would hit me across the face. I was, and still am, terrified. I told him "No" and begged him to go away. All the time his fingers were tickling me between my thighs. [21]

Overcome by rage and despair, Colette drops out of sight. Distraught and lonely, Walter returns to Barbara, who at last asks her philandering husband for a divorce. On his Sausalito barge he produces "Alone," a painting of a waif sitting on a vast cosmic stairwell. Walter Keane describes it thus:

Here is my symbol of humanity "Alone" with infinity but in the company of the always here and the constantly now. The child represents the isolation and stresses of humankind as she perches precariously on the vast stairs of life. The distant side of the stairs is the brink of the universe; the near side, in muddy reflection, is the edge of the abyss of human degradation. The spheres in the beyond draw us irresistibly by gravitational forces, pulling us back through the eyes of the child which are but sights into the blue-black of space and time. [22]

He asks himself, "Was my eternal romance to be with a palette and a brush? Would art forever be my only real love?"[23]

Walter spends the next few years living it up in the jazz clubs of New York and North Beach hangouts like Vesuvio, where he drinks until the wee hours with beatniks such as Jack Kerouac and movie stars like Kim Novak. On a fateful day in the spring of 1955, during the annual outdoor exhibition of the Society for Western Artists near Fisherman's Wharf, Walter meets a "slender, young blond woman" named Margaret, his soon-to-be second wife. According to Keane's memoirs, the star-crossed meeting would one day lead to his horrible betrayal by a vengeful ex-wife.

We can only speculate as to Walter's state of mind when he wrote his autobiography. Did he believe every word he wrote or did he come to believe his own press materials? Or was he a remarkably cynical man? If he was careful to tell the truth, Keane actually had an interesting story to tell. Though his treatment of Margaret cast a permanent shadow over his achievement, it can't be denied that Keane, a man with only the most cursory experience selling art, took a small art gallery and turned it into a million-dollar concern.

Behind Keane's outgoing persona was a secretive and enigmatic man. Regarding the details of his early life, he left behind a number of unknowns, false paths, and gray areas. Separating fact from fiction was not an easy task. In some instances, when there was little information available about a particular area of his life and his statements appeared both plausible and seeming to lack any ulterior motive, we've had to (reluctantly) take him at his word.

We can say for certain that Walter Stanley Keane wasn't born in 1920, 1921, or 1923 as he told the newspapers at various times. Social Security and Federal Census records indicate that Keane was actually born years earlier on October 7, 1915 in Lincoln, Nebraska. He would leave his hometown at the age of twenty and never look back, but the years he spent in Nebraska left a lasting impression.

At the time of Walter's birth, the U.S. was just two years away from entering the First World War. Nebraska, like other agricultural states, was enjoying a short-lived economic boom due to wartime disruptions in European trade. The Cornhusker State at that time was also a popular destination for countless European immigrants who availed themselves of the cheap land then offered to settlers. Other immigrants sought work on the railroads or in the meatpacking industry. Considering that Keane spent his childhood years in a city populated by immigrants from Germany, Czechoslovakia, Bohemia, Sweden, Russia, and other nations, it's unsurprising that he felt at home in a large cosmopolitan city like San Francisco and possessed a lifelong love of travel and exotic places.

His father, William R. Keane, was an Irishman born just a few years after the Civil War ended. The elder Keane listed his birthplace as Iowa on a turn-of-the-century census form, but Walter stated in his autobiography that his father, like many immigrants at the time, falsely claimed to be native-born to avoid discrimination. Walter said that his father was actually born in Killaloe, a large historic village on the River Shannon in the Midwest region of southern Ireland. He remembers the elder Keane as a tall, imposing man with red hair and freckles, who possessed endless ambition and drive. In his autobiography he also revealed that his father was something of a womanizer, a man who at the age of 89—the year he died—still kept a handful of young women as mistresses.

Keane Sr. was a successful subcontractor for General Motors, and his specialty was making convertible tops. William was a practical-minded man who apparently was contemptuous of artists. He also had a well-honed eye for business opportunities, which must have influenced his son to become an astute businessman. William would often stress to Walter that he could do whatever he wanted in life so long as he could find a way to pay the bills.

Keane's mother Alma was fifteen years younger than her husband and originally hailed from Denmark. She immigrated to the U.S. at the age of four and was of mixed Scandinavian heritage, the daughter of a Danish mother and a Swedish father. Walter remembered Alma as a beautiful but long-suffering woman who became a "virtual slave" during her marriage as she worked night and day running the large Keane household. Other than attending services at the local Lutheran church, he recalled that her life consisted of an endless round of scrubbing, sewing, and preparing meals.

It's hard to say whether the Keanes were a happy or devoted couple but the union was a prolific one. As ancestral records show, the marriage produced ten children. Along with his nine other siblings, Keane also grew up with four half-brothers and sisters from his father's first marriage. Considering he spent his childhood vying for attention with thirteen other siblings, it's not hard to see why Walter was destined to become a man who craved the spotlight.

According to Keane, while growing up he was a shy, withdrawn, and often sickly blond boy with sparkling blue eyes who frequently wore the hand-me-downs of his older brothers. If he often felt lost and starved for attention, there were also fond memories of family life. In a revealing 1984 interview, Keane wistfully recalled his childhood years in Nebraska and had happy memories of the Sunday gatherings at his grandmother's house. "We had poets, writers, artists, big family parties every Sunday," he remembered.[24]

If his father taught him the importance of thrift and hard work, it was Alma and her artistically inclined family who cultivated Walter's lifelong appreciation of the fine arts. "My mother's family were musicians and artists," he told an interviewer, "my father's were all businessmen."[25] Keane would also repeatedly mention his Swedish grandmother as being a major influence in his life.

If Walter occasionally spoke about his humble beginnings growing up in a white clapboard house in the Midwest, there were years that

22

he refused to mention, much less discuss. Keane never spoke about the Great Depression and how his large family fared during those difficult years. When Walter was still a teenager, Nebraska and other states in the region were blindsided by the Dust Bowl, one of the worst ecological disasters in twentieth-century history. The six-year period of prolonged drought and violent dust storms devastated crops and farms, and plunged hundreds of thousands of rural families into poverty. The exodus of farmers and sheer loss of wealth only amplified the effects of the Depression in states like Oklahoma, Kansas, and Nebraska.

Keane was an unwitting bystander to another historic occurrence. When he was barely four years old, the Eighteenth Amendment was enacted by Congress, making it illegal to sell, manufacture, or transport alcohol until Prohibition was repealed over a dozen years later. This was a contentious issue in Nebraska that pitted the wealthier and more God-fearing Protestant families ("drys") against the state's hard-drinking immigrant population ("wets"). Before the ink was dry on the Volstead Act, which enforced the nationwide liquor ban, Nebraskans who opposed Prohibition began setting up backyard stills throughout the state. The Keane family was staunchly in the pro-drinking camp, and Walter recalled in his autobiography that his father was fond of making homebrew for family gatherings. Perhaps Walter's lifelong love of alcohol began in his teenage years during Prohibition, when downing a shot of illicit corn liquor was considered an act of political protest.

Lincoln may have had its charms, but by his late teens Walter was already plotting his escape. There was one destination he had in mind: California. Keane would later say his love affair with the Golden State began with a car trip he took with a fellow Nebraskan when he was seventeen (approximately 1932). Setting out from Lincoln, the two men journeyed nearly two thousand miles, stopping off in Los Angeles and Santa Monica and then heading north. As Keane took in the Northern California landscape, he marveled at the beauty of Carmel

and Monterey. "We took the ferry over to Berkeley and I walked up University Avenue to the UC Campus," Keane recalled. "I stood there looking out over the Bay, at San Francisco, at Marin County. Then I decided I'd make that my home."[26]

If Walter saw a glorious future for himself in sunny California, he wasn't alone. When Keane put Nebraska in the rearview mirror in 1935, he joined the hundreds of thousands of Depression-era migrants seeking a better life out west. In the Dust Bowl states, it was commonly believed that if a man had a car that ran and could scrape together the gas money, he could take a stab at rebooting his life in the land of orange groves and movie stars. If the newcomers had high hopes, not unlike the families depicted in John Steinbeck's Depression-era novel *The Grapes of Wrath*, they were bound to be disappointed. The state didn't have the resources to assist the large influx of impoverished economic refugees, and the locals, who were struggling to find work, didn't appreciate the extra competition.

When he was a senior citizen reminiscing about his early days in the state, Keane told an interviewer that when he arrived in California in the 1930s, he immediately enrolled at UC Berkeley. After college, he explained, he started a small business with an unnamed partner. The two began renovating and selling homes in the Berkeley area. The partner was responsible for the architecture, while he, ever the artist, designed the interiors. According to Keane, the fledgling two-man operation grew into his successful Berkeley real estate firm.

This sounds plausible enough, and Keane even mentions that he received a degree in Business Administration in his autobiography. However, there is no record of Keane attending UC Berkeley. A likelier scenario has Keane arriving in Southern California before his move to Berkeley.

The obituary that appeared in the *San Francisco Chronicle* in December 2000 and Keane's Wikipedia page both allege that he

arrived in Los Angeles first and attended Los Angeles City College (LACC) on Vermont Avenue. He is even listed on various web pages as one of the school's many celebrity alumni, alongside notables such as Clint Eastwood, La Monte Young, and Gene Roddenberry. Along with attending LACC, perhaps the most significant event that occurred during Keane's stay in Southern California was when he met, and subsequent married, his first wife Barbara Ingham.

It's likely the two met at some point while she was completing her undergraduate degree at the University of California, Santa Barbara (UCSB), roughly a hundred miles north of Los Angeles. Unlike her Nebraska-born husband, Barbara had roots in California, born in 1918 and raised in Pacific Grove, a picturesque coastal town between Carmel and Monterey. Her father, Arthur Ingham, served as the principal of Pacific Grove High for twenty-eight years.

Barbara proved to be a capable student, attending UC Berkeley and then transferring to UC Santa Barbara, where she went on to earn her bachelor's degree in Home Economics in 1939. While it's tempting to dismiss "Home Ec" as lightweight, it's worth remembering that in the years before WWII women were discouraged from working, and expected to view themselves first and foremost as wives and mothers.

Walter and Barbara married in June 1941 and settled in Berkeley. Despite Walter's claim that he started his real estate firm from the ground up with a business partner, Barbara may have been his true assistant. She became a licensed broker herself and likely possessed the knowledge of the area and local connections Keane needed to get started.

Just a few months after they got married, Barbara Keane appeared in a short article in the *Oakland Tribune* regarding her ten-week course in "The Art of Entertaining" at the Oakland Evening High School. A year later, with the U.S. embroiled in the war, she offered a similar course which offered to teach how "to establish

continued social fellowship during the war emergency" and "how to apply ingenuity and imagination in planning parties and meals which are economic and inexpensive."[27] She also attended UC Berkeley at the time. Records show that Keane's wife completed her master's degree in 1943. Her 182-page thesis was titled *The Clothing Industry in California.*

Did Keane actually serve in the military during the Second World War? In 1964, a business associate of Keane's, Paul Nelson, told Iowa newspaper the *Waterloo Courier* that he met Walter when the two were stationed in Germany during the war. According to the article, Keane "began serving with allied troops in Germany in his early 20s," where the "desolation of Germany and its effect on the German people colored the young artist's entire career."[28] However, a Freedom of Information Act request filed with the National Archive, Military Personnel Records Center could find no record of Keane's military service. Additionally, when Keane was in his early 20s, WWII had not yet broken out. So why did Nelson claim he served in Europe with Keane? Perhaps context is everything.

Nelson earned a comfortable living as a kind of advance man for Big Eye art in the Midwest. The Iowan sold high-quality lithographs of Keane paintings and even traveled throughout the region giving lectures at various colleges discussing Walter's life and the fascinating background behind his paintings.

If Walter did serve overseas, he was home before the war concluded. Advertisements for Keane's real estate firm appeared in the *Berkeley Gazette* in the early months of 1945. The Keane business was located just a few blocks from the UC Berkeley campus at 2077 University Avenue. The years after WWII were an opportune time to sell real estate. Various wartime-related industries put down roots in Northern California while thousands of employees were settling throughout the region. Construction of new homes had ground to a halt during the Depression, and as a result many struggled to find

living space. Keane found a lucrative niche for himself in Berkeley.

The Keanes experienced tragedy when a young son died during childbirth in the mid-1940s. In 1947, Barbara gave birth to a daughter, Susan (Walter got his daughter's birth date wrong in his autobiography). And with this new addition to the Keane family, Walter seemed to have all the trappings of material success: a beautiful home, loving wife, a new family, and two expensive foreign cars in the garage. But a few years later, the family would travel to Europe on a lengthy trip, and it appears that there the marriage encountered speed bumps. When the couple traveled to Paris and Germany for educational purposes, Walter apparently studied art, while Barbara explored dress design and cooking classes. The family returned via the *Queen Mary* in August 1950 and the couple would be divorced less than two years later.

Records are sparse on the period between the family trip to Europe and when Walter first met Margaret. According to his autobiography, Walter spent the early 1950s jetting back and forth between California and various foreign destinations to perfect his Big Eye technique, exhibit paintings, and track down starving children to model for him. Apparently his work did not go unnoticed. "Business was good," he recalled in his autobiography,. "From San Francisco to New York to Paris, the wide-eyed waifs were recognized as uniquely mine.[29] Apparently politicians, movie stars, and art dealers were all buying copies of his paintings. Knowing Walter's later failures in court regarding the true painter behind the big-eye waifs, one could rightfully ask, "What paintings was he selling?"

Unfortunately, Walter's freewheeling partying and art obsession didn't mesh well with Barbara's academic career, leaving the couple without any time for each other. Soon the marriage fell apart. As Keane observed, "we were in love with our careers but not each other."[30]

He would tell a similar story to Vera Graham, a *San Mateo Times* reporter who wrote a glowing profile of Keane and Margaret in 1964.

"Even a cursory reader of art news knows of Walter Keane's decision in 1947 to abandon his highly successful real estate career," Graham wrote, and "how he offered his first wife the opportunity to join him in his search for his life's work—which at the same time meant searching for a purpose and searching for himself…understandably to most, the lady bowed out." [31]

Graham, a Keane sycophant, went on to describe Walter's valiant struggle after the marriage ended, as he sat hunched over an easel in a "small barren crowded room, in the time-worn tradition of the struggling artist" trying to bring to life the big-eyed children who "wouldn't let him alone." [32]

There are a few problems with Graham's version of events. If Barbara rejected his initial desire to paint in 1947 and "bowed out" of the relationship, why would she have his child and continue staying married to him for five more years? And did Keane really "abandon" his business in 1947? Margaret Keane had a distinctly different memory when asked to recall her first encounter with Walter.

"He still had his real estate business," she remembered in a 1990 interview. "But when I first met him I thought he was an artist," she explained. "I met him at a San Francisco Art Festival, a yearly thing. I was there doing portraits and he was showing these Paris street scenes. By the way, the Paris street scenes did not have any faces in them. Done with a lot of palette knife, thick paint, entirely different from the way I paint."[33]

Keane wrote in his autobiography that he met Margaret in "late Spring of 1955" at the annual outdoor exhibition of the Society for Western Artists. Walter claimed he was there to show his stylized paintings of the "lost children" he'd encountered in Hong Kong, Tahiti, and Chinatown in San Francisco. It seems likelier that he was showing Paris street scenes and not all the alleged works he'd done in those exotic settings.

During the early 1950s, when Keane claimed he was developing his art and showing it to famous people, it's more likely he was

selling real estate and appearing at local art festivals. Whether he ever produced anything worthwhile remains yet another mystery. His autobiography includes several sketches and paintings allegedly from his salad days, but it seems probable that whatever paintings he possessed from the period may not have been his own work. Some have speculated that at the very least, Walter helped with some of the backgrounds of Margaret's paintings. Perhaps the only certainty is that on that fateful day in 1954 when Walter met Margaret, his dreams of artistic fame came much closer to being realized.

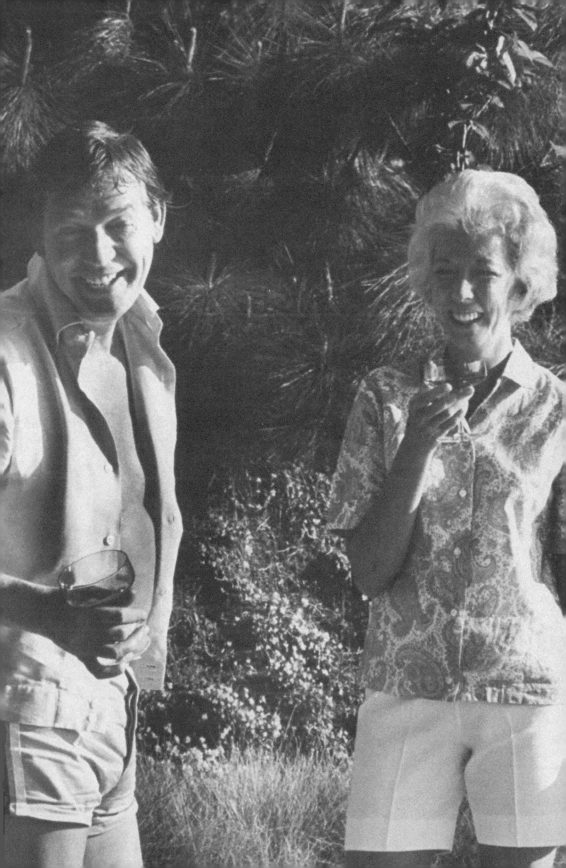

CHAPTER *THREE*

Margaret:
Life Before Walter

Amidst all the public acrimony that later transpired between the Keanes, it's easy to forget that in the beginning they were very much in love. Margaret has never denied that at the time of their whirlwind courtship she found Walter's charisma appealing. "For years he was very charming and just swept me off my feet," she recalled in the early 1990s. "I thought he was an artist who painted these street scenes and was totally captivated by him."[34] And the two had much in common. Both of their marriages had recently gone sour and they were each trying to raise young daughters. And, regardless of the reality of Walter's supposed talents, they both shared a passion for art. If the relationship was doomed from the beginning, at least in those early years, while they may have struggled, life was good.

Walter didn't remember things that way. He wasn't going to forgive Margaret for breaking her vow of silence and destroying his reputation. So when he wrote his autobiography over three decades later, the embittered ex-husband set out to destroy her reputation.

For sheer venom, few books can match *The World of Keane*. Keane's hatchet job was outrageous and its underlying hostility toward his ex-wife is hard to ignore. It's a testament to Margaret's good nature that

she has seemed more bemused than angered by Walter's strange re-telling of their life together. Even at his most generous, Walter depicts Margaret as talentless, pathetic, and mentally unhinged. When he takes the gloves off in some of the more acrid passages, the reader is left with the impression that she's a boozing, sex-starved psychopath.

From the very outset, when she bumps into Walter in 1955 (Margaret has said it was 1954) at the outdoor exhibition of the Society for Western Artists at the aquatic park near San Francisco's Fisherman's Wharf, Margaret appears as more groupie than fellow artist. "My name is Margaret," the slim blonde with the slight Southern accent allegedly tells Keane, "I know who you are, and I love your paintings. You are the greatest artist I have ever seen." And, after shooting him an "appraising glance," she takes it up a notch. "You are also the most handsome," she adds. "The children in your paintings are so sad. It hurts my eyes to see them. Your perspective, the magnificent colors and textures and the sadness you portray in the faces of the children make me want to touch them."[35]

Of course Keane isn't the kind of artist who lets just *anybody* touch his canvases, and he coldly reprimands her. "No," he responds curtly, "Never touch any of my paintings." [36] Margaret apologizes and explains that other than a part-time gig painting neckties, she has little background or training in the fine arts.

Later, when the art show ends, she reappears, offering to help him pack up all of his paintings. Ever the obliging gentleman, he invites his new admirer to join him and a handful of North Beach artists for dinner and drinks. Once the booze starts flowing, it's pretty clear she has one thing on her mind—and it isn't art. After several rounds, at her repeated urging, they retire to Keane's place, where she surprises Walter by emerging nearly naked from the bathroom. Once again Keane admonishes her: "When I make love with a woman, I unwrap her." In the midst of their lovemaking Margaret hurries out of Walter's apartment to return home to husband and daughter. "You are the greatest lover in

32

the world," she supposedly announces before her sudden departure.[37]

Two weeks later, Margaret reappears at Walter's door, suitcase in hand, begging to become his disciple. Keane had already noticed that she had an odd way of covering her face when she talked, and he now learns that his would-be disciple has "buck teeth" and "no chin." Almost against his will, Walter offers to buy his insecure new student orthodontia and plastic surgery. He also helps her pick out a more tasteful wardrobe. Of course, Walter has his own problems. Stymied by the lack of visitation rights with his daughter Susan, an attorney advises him to remarry in order to convince the court that his home has a family atmosphere. Despite his personal worries, he throws himself into the task of building a better Margaret:

"The transformation of Margaret into a complete person whom she, herself, could live with and like, loomed as a monumental task. There was, however, something enticing about the challenge. I envisioned myself as a sort of Henry Higgins with Margaret as a modern-day version of Eliza Doolittle."[38]

33

Walter's instructions also included teachings on social graces: "To accompany Margaret's new wardrobe, I suggested a list of greetings and topics for conversation on specific social occasions. I encouraged her to practice them with certain graceful gestures in front of a mirror."[39]

Then came painting: "To give Margaret instruction at the most basic level, I bought her a projector, then you place a photo or page out of the artist's book in the projector and project it onto a canvas. Trace it on the canvas. Next step, fill in the colors much like a numbered painting, designed for a child. This was her beginning of copying other artists' work. She worked at this method steadily, copying great works of Modigliani and El Greco. I reemphasized to her that once she had mastered an artist's technique and learned his effects, she must destroy the paintings she had copied and go on to another artist. If she did so, she would one day have the knowledge to work on her own and to create her own style."[40]

Of course, despite his best efforts, Walter, the long-suffering mentor, fears that she isn't making progress. "If I had enough foresight at the time," he reflects, "I would have realized that Margaret's psychological problems were so deeply rooted that even my attention to her personal and professional well-being was insufficient to bring real change in her attitude and personality."[41] It seems she developed a creepy attachment to her well-meaning benefactor. As she begins to exert pressure on him to make their relationship more permanent, and his fears grow over not being able to see his daughter Susan, they take a trip to Hawaii, where the drinks flow freely. When a sobbing, drunken Margaret begs him to marry her and reunite her with her daughter, the big-hearted Keane, in a booze-soaked reverie, conjures in his mind "the lost, suffering children of Berlin and 'the lonely child, Jane, at home in California without her mother.'" [42]

Still tipsy from a few drinks, Keane relents and calls a friend in Waikiki to be best man at the afternoon ceremony. As the guests gather to celebrate the new couple, the bride can't be found and after a frantic search, Walter discovers Margaret *in flagrante delicto* with several parking lot attendants. In desperation he consults his attorney, who cautions him that an annulment will endanger visitation rights with Susan. Keane reluctantly decides to follow through on his union to Margaret and at least simulate the appearance of a happy marriage. "Now I had to live with this error," he writes bitterly, "and make the best of it for everybody's sake."[43] Despite her constant drinking, he makes a home for Margaret and her daughter Jane, and hopes that the new marriage won't get in the way of his flourishing painting career.

Or so Keane would have you believe. Other than the couple's wedding in Hawaii and Margaret having a daughter named Jane from a previous marriage, Walter's account appears to be a sinister form of payback. His depiction of Margaret as an artistic failure with a drinking problem hits uncomfortably close to the source.

34

Margaret has always been reticent about discussing her life, particularly the years before she met Walter. This may explain why he felt so comfortable taking liberties with her background. Even when the couple was interviewed for newspapers and magazines, Margaret rarely spoke about her pre-Walter days. Not like reporters found the subject pertinent to their stories—most articles focused on Walter's tormented postwar wanderings through Europe.

We do know that Margaret Doris Hawkins was born in Tennessee in 1927. Hawkins is a Scots-Irish last name, and it is likely that Margaret's ancestors can be traced back to the wave of immigrants who fled the Irish province of Ulster and settled in Tennessee in the eighteenth and nineteenth centuries. Like many natives of Tennessee, she was raised as a Methodist. She would later say the experience left her with a "deep respect for the Bible...although I knew very little about it."[44]

Like Walter, she would grow up in a state that was severely impacted by the Great Depression. Tennessee farmers were already struggling during the 1920s when the price of tobacco and cotton began to fall. Yet it was the 1930 collapse of Caldwell and Company, a Nashville-based megabank, which sent the Tennessee economy into free fall. The powerful firm controlled the largest chain of banks in the region and when Caldwell went under, the disaster set off a wave of panics, bank runs, and bankruptcies, and over a hundred banks and financial institutions went out of business. The ensuing cash crunch left farmers and businesses unable to obtain much-needed credit. Cash-starved employers slashed jobs and wages. As unemployment swept through Nashville and other nearby cities, beggars became commonplace, desperate families waited hours in breadlines and soup kitchens, and the homeless took up residence in crude "shantytowns."

A background search yielded a faded census record from 1930 that lists a Margaret D. Hawkins, approximately the same age as the artist,

35

living with her parents in Dyersburg City, Tennessee, roughly 170 miles west of Nashville.

The parents are listed as David R. Hawkins, a native of Alabama, and Jessie J. Hawkins, who was born in Tennessee. Both parents were born at the turn of the century. David was apparently employed at the time as an insurance agent. The small family rented a home in Dyersburg for $25 a month. In light of the state's dire economic situation, the Hawkins family appeared to be doing well.

Most of Margaret's accounts of her childhood are dominated by what would become her life's twin obsessions: art and spirituality. "I grew up in the Southern part of the United States in the region often referred to as the 'Bible Belt,'" she recounted in a brief autobiography written in 1975 for *Awake!*, a Jehovah's Witness publication. She went on to describe herself as someone who "grew up believing in God, but with a lot of unanswered questions."[45]

Margaret described herself as a "sickly child...often alone and very shy," with an "inquisitive nature" that frequently left her wondering about "the purpose of life."[46] The frequent bouts of illness left her by herself for long periods of time and when she wasn't given to contemplating spiritual matters Margaret also developed another precocious obsession.

"I have always loved to paint," she remembered in a 2012 interview. "As a child I was drawing all the time."[47] The young artist sometimes earned the ire of her teachers by doodling in the margins of her textbooks—interestingly, even those early drawings showed her lifelong obsession with eyes. In elementary school, her parents enrolled her in art classes and she transitioned from sketches to painting and other mediums. As she was a shy and soft-spoken adolescent, painting provided a valuable outlet for expressing her emotions—a kind of personal art therapy that she would carry on for the rest of her life.

Margaret spent her teenage years in Nashville, and she would continue her artistic studies at the Watkins Art Institute (now the

Watkins College of Art, Design & Film). The school, which has been in existence for over a century, was started in 1885 with a sizable grant from the estate of Samuel Watkins, a successful local businessman. In his will, Watkins set aside some property he owned in the center of Nashville and a $100,000 endowment for the creation of a school for students needing education in what he called the "business of life."

Although the Institute primarily focused on art, over the years the school would provide a variety of other educational services to residents of Nashville. When immigrants flocked to the city in search of jobs in the early twentieth century, Watkins provided a variety of courses to help the new residents adjust to life in America. During the Depression and WWII years, Watkins instructors held classes to help women enter the workplace. Later the school assisted returning veterans seeking to earn their high school diplomas. Although Margaret mainly took art courses, she also enrolled in some of the more practical classes offered to women at that time.

A *Modesto Bee* article from 1959 indicates that Margaret later attended classes in New York at the Traphagen School of Design.[48] The innovative school is remembered as one of the first learning institutions dedicated to fashion technology and design. Set conveniently close to the garment district on Seventh Avenue in Gramercy Park, the institute was the brainchild of Ethel Traphagen. The influential designer believed that the fashion industry would benefit from a school that would give men and women interested in entering the field a brief but thorough background in design and illustration. Traphagen began offering classes in 1923, and a number of illustrious designers like Geoffrey Beene, Anne Klein, and James Galanos would later pass through its doors.

It's not hard to see the Traphagen influence in some of Margaret's paintings of long-necked adolescents. The symmetry and lines of her paintings are not unlike the illustrations of models that appeared in fashion magazines of the mid-twentieth century. During those early

37

years she also attended courses at both Jacksonville Junior College in Florida and later (during her first marriage) at Chaffrey Junior College in Ontario, Canada.

Her experiences studying art left a positive impression. Walter and Margaret publicized that they had set up a foundation to provide funding to art schools in the U.S., Europe, and Japan. On her Facebook page, Margaret lists her chief inspirations as "Modigliani for figure and form," and "Van Gogh and Gauguin for color and composition."

Were there other influences? In a very short biographical monograph, author Jennifer Warner speculates that Margaret may have been inadvertently influenced by Frederick Dielman, a popular nineteenth-century artist known for his sometimes ironic and humorous kitsch paintings.[49] Warner specifically cites *The Widow*, one of his more popular pieces, as a possible precursor to Margaret's later work. The painting depicts a cat with Keane-like oversized eyes and a ruffled collar staring mournfully at the viewer. It's hard not to notice the similarities between Dielman's somber feline and Margaret's later animal paintings. She may have run across his work, but this could just as easily have been a simple coincidence.

Waif paintings were also a widely popular phenomenon in France beginning in the late nineteenth century. Perhaps this can be traced back to the 1862 publication of Victor Hugo's *Les Miserables*. The classic novel is often remembered for the author's chapter-length asides on a variety of topics, ranging from the French language to the Paris sewer system. One of Hugo's digressions discussed *titis*—the poor street children of Paris. The novel also tells the tragic story of *Gavroche*, a good-natured but streetwise outcast who lives in a hollowed-out elephant statue. Considered one of Hugo's most sympathetic and endearing characters, the fictional street kid captured the hearts of Hugo's readers, and struggling artists would often sell drawings of *Gavroche* on the streets of Paris.

Among the most popular illustrators of street children was Francisque Poulbot (b. 1879), a talented French draughtsman and writer who created a series of images depicting the poor children of Montmartre. Unhappy with the German-made dolls sold in France at the time, Poulbot also designed a series of memorable dolls. Along with his art, writing, and poetry, Poulbot spent years operating a dispensary for needy children. If his children didn't have Margaret's dramatic oversized eyes, they possessed the same emotional appeal, and perhaps Margaret drew inspiration from them.

Whatever influences she may have had, Margaret faced strong societal pressures to marry and start a family. Once the war was over, women were encouraged to become married stay-at-home mothers who cooked, cleaned, and took care of kids.

At some point in the late 1940s, Margaret joined the ranks of newly-married housewives. She met and married a man named Frank Ulbrich, and the young couple had a baby daughter, Jane. Public records reveal a Frank Ulbrich who passed away in 2002. Ulbrich was a longtime resident of Northern California who was married twice, once in 1948 in New York, and again in 1955 in California. Margaret was studying at the Traphagen school in New York at the time of Ulbrich's first marriage, and the two likely met there and relocated to California.

Even while she ran the household during her first marriage, which would quickly end in divorce, Margaret continued to paint and experiment with oversized eyes. "When my daughter was a baby," she recalled in an interview, "I started doing her portrait and then my neighbors wanted me to do their children's portraits, and I did them with larger eyes than normal. [The] eyes were always large." [50]

Margaret's silence about her first divorce suggests that it was a painful period in her life. As she later wrote in her brief autobiography, "My road to popularity in the art world was a rocky one. There were two wrecked marriages and much mental anguish along the way." [51]

In a likely attempt to undermine her reputation, Keane wrote in his autobiography that Margaret told him that she had "grown up in a broken home, bruised and battered by an alcoholic father."[52] If there was physical abuse in her childhood home, she never tolerated it during her second marriage with Walter. "One thing I stood up for: he hit me once or twice and I made such a to-do about it that he didn't do that again," she later recalled. "That's the only thing I stood up for."[53]

Margaret often said that her weeping waifs were really a reflection of her own anguish; perhaps she experienced periods of deep unhappiness in her early years that followed her through much of her life. Although we can't be certain about the causes of her sadness, it's likely she had a difficult life growing up and finding her place in the world. Yet she never once doubted her abilities as an artist. If she was shy and withdrawn around people, throughout her life painting remained a source of constant joy and gratification; it was her primary means of personal expression and a vital outlet for her emotions.

She'd spent years painting in relative obscurity when she first met Walter in the mid-1950s, but all that was about to change. If Margaret didn't know it at the time, her affable husband possessed a certain creative genius when it came to the art of selling a product. In a few short years her paintings would become a nationwide sensation. And it all began in North Beach.

MDH
MARGARET
KEANE

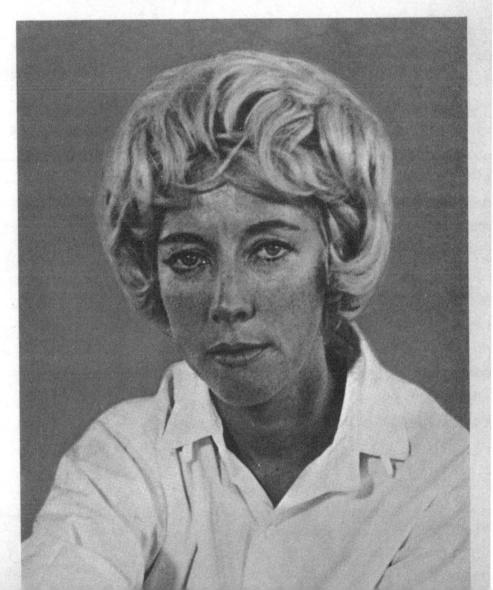

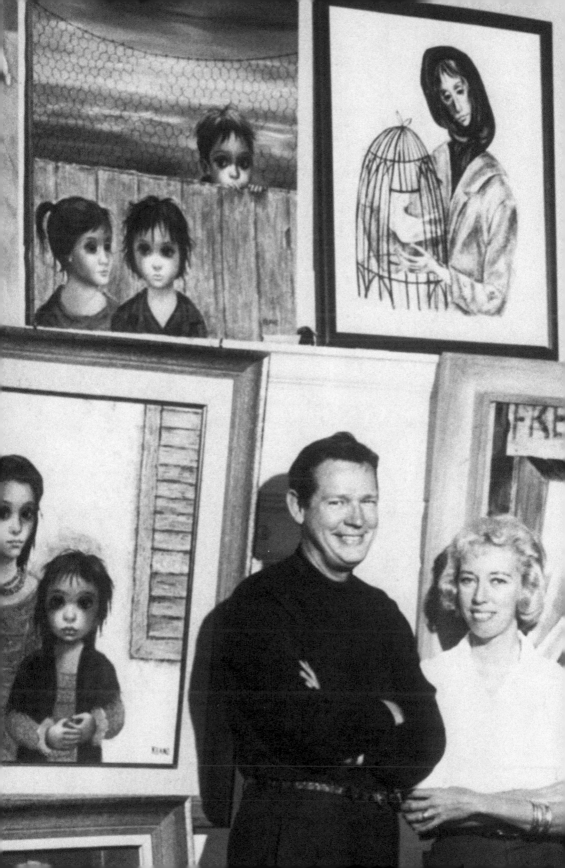

An Evening at the hungry i:
North Beach Beginnings

If the fifties are often remembered as a time of one-size-fits-all conformity, there were also a few outposts of resistance—such as San Francisco's North Beach district. The colorful neighborhood, located just south of Fisherman's Wharf and north of Chinatown, had a reputation in the mid-twentieth century as a haven for misfits and nonconformists.

The area's compact, pedestrian-friendly layout and sizable Italian population (it was known as the city's Little Italy) gave it a distinctly European flavor that proved irresistible to suburban escapists, wannabe artists, mystics, radicals, poets, and eccentrics. Rent was cheap, dining out was affordable, and the area was littered with European-style bakeries, cafés, and coffeehouses. If you wanted to live the bohemian lifestyle but couldn't afford the airfare to Paris, North Beach was the next best thing.

Perhaps because it was once part of San Francisco's historic Red Light District, the area was also known for its freewheeling party atmosphere and tolerance toward gambling and other vices. If some of the police who patrolled North Beach were known for strictly enforcing the law, others were more than willing to look the other way if the price was right. It's not exactly surprising that the area would

later become the setting for the country's first topless bar. If you liked the nightlife, there was no better way to unwind than a spirited crawl through North Beach, where there was no shortage of bars, nightspots, and jazz clubs.

New arrivals and weekend visitors were often fascinated by the cast of characters who called North Beach home. There were beatnik poets, local gangsters, barflies, free love enthusiasts, Zen Buddhists, and a rich assortment of oddball types. The district also had a reputation as something of an artist's colony. Creative types had been gravitating to the area as far back as 1915, when many of the artists hired for San Francisco's Pan Pacific Exposition discovered the charming Italian neighborhood and decided to settle there. The nearby California School of Fine Arts (now the San Francisco Art Institute) also provided the neighborhood with a steady stream of student-artists looking for affordable housing—and who often ended up staying permanently.

San Francisco was also the final stop for many servicemen heading overseas during WWII. Many gay soldiers and sailors who passed through North Beach found much to like about the area's tolerant climate and returned, adding yet another flavor to the neighborhood's eclectic mix. The influx of creative talent over the years, both gay and straight, contributed to a thriving postwar art and poetry scene. One North Beach settler, poet Allen Ginsberg, would become a Beat-era icon when he read *Howl*, an inspired free-verse epic at the nearby 6 Gallery in October 1955. It was during this period of postwar creative ferment that Walter and Margaret Keane began selling Big Eye paintings, and they couldn't have chosen a better setting.

The Keane Gallery, which opened in 1958, was located right in the heart of North Beach at 494 Broadway (now the site of the Green Tortoise Hostel and Adventure Travel Company). Walter, who called the neighborhood his "favorite hangout" in his autobiography, seemed to relish the electric nightlife, and numerous bars and restaurants scattered throughout the area.

Back then, belonging to the counterculture was perhaps more a state of mind than a fashion statement—though some had goatees, the love beads and long hair would come later. If you trafficked in interesting ideas or were drawn to art or poetry, there's a good chance you'd fit in with the North Beach bohemian crowd. As the married parents of two young children, Walter and Margaret may have had one foot in the "square" world, but in their own way, the two were outsiders just like the beatniks who hung out in seedy bars on Grant Avenue. Back in the early days, Keane art existed on the furthest fringes of the artistic universe. "We grew up, you know, *beside* the art world, not in it," Walter once explained to a reporter. "We couldn't penetrate it."[54]

The art world meant New York, a city that had shoved Paris aside as the global center of avant-garde art. The postwar boom had given new momentum to a thriving domestic art market; in New York alone, the number of galleries and collectors had surged from a few dozen into the hundreds. As America emerged from the war with all the trappings of a superpower, the new emphasis was on the country's homegrown artists, who had long been ignored in favor of their French counterparts.

Critics of the day said it was time for a uniquely American painting style that would cast aside all European influences and break new ground. Non-objective art was the new fascination. Why waste your time simply reproducing an image? Why not use the canvas to display color, line, and space in dramatically new ways? As art historian Erika Doss explains in her *Twentieth-Century American Art* (Oxford University Press, 2002), "Postwar artists were encouraged to develop a *free-form* aesthetic; a new modern art that abandoned the stylistic conventions of the past and was predominately self-reflexive, focused on the qualities of its particular medium and the 'feelings' of its individual makers."[55]

American Regionalist art that pandered to the masses in the early twentieth century just wasn't in fashion anymore. The rise of fascism

had influenced critics like Clement Greenberg and other New York intellectuals to speak out against art that appealed to the unsophisticated or attempted to arouse or inspire the public. They wanted to see an American art movement appeal to discerning art enthusiasts.

As a result, Abstract Expressionism couldn't have emerged at a more opportune time. A small group of artists, who were mainly based in New York, explored the plight of themselves and others by blending colors and textures to create intense, chaotic, and distinctive paintings that were unlike anything Europe had ever produced. The groundbreaking work of "Action" painters like Mark Rothko, Willem de Kooning, and Jackson Pollock would help launch what would become one of the first American art movements to have a global impact.

In California, modernist approaches were beginning to have an impact. Many Bay Area painters were experimenting with abstraction, minimalism, Pop Art, and other avant-garde approaches. However, if abstract painting had become a favored style in New York, many North Beach artists were moving away from the art establishment for newer directions.

In 1950s North Beach and throughout the Bay Area, "funk/assemblage" art was becoming widely influential. The Funk artists, who rejected the art establishment, revolted against the tendency among abstract painters to ignore external reality in favor of experimenting with color, line, and texture. Idiosyncratic painters, such as Bruce Conner and George Herms, were influenced by the Beat-era ethos that beauty can be found in the everyday and commonplace. Many of these painters integrated tattered news clippings, garbage, cheap fabrics and other found materials into their collage-like paintings. Whatever society threw away, they reasoned, must have some value.

If Keane wasn't exactly a fan of this new painting style, he shared with the Funk artists a disdain for abstract painting. "To me, a painting must have emotion to live or breathe," he once remarked. "Abstract

art primarily has shock, but no life."[56] However Walter may have felt about Abstract Expressionism and other modernist painting styles, he was obviously aware that if he and Margaret were going to ignore the prevailing trends, making a living selling art was going to be an uphill struggle.

The Keanes were thousands of miles away from New York, where the majority of the nation's art buyers and collectors lived. San Francisco may have been the cultural jewel of the West Coast, but the city offered fewer opportunities to up-and-coming painters—especially if you were scratching out a living on the fringes in North Beach and didn't have much of a following.

Walter must have implicitly understood that he and Margaret weren't going to get very far pandering to the avant-garde. Selling in volume to the public was the key to success, and at least in North Beach, if you wanted your work to be seen you didn't wait around hoping to be discovered, you had to roll up your sleeves and take a DIY approach. Local painters sometimes banded together, pooled their resources, and opened small storefront galleries to display their work. These artist-run spaces included the short-lived Batman Gallery, the historic 6 Gallery, and in North Beach, the Dilexi. Bars were another popular venue for local artists, who sometimes paid the owners to hang their paintings on the walls.

Keane was a practical-minded man with a good head for business, so he likely paid attention to this sort of guerrilla marketing, looking for any opportunity to push the paintings. Bob Miller believes that one of the keys to Keane's success was that he never sat still waiting to be discovered. "When other local artists were sitting around complaining and starving," he observed, "Walter was out there selling his wares."

If he couldn't get the paintings into museums or influential galleries, he'd bring the work to the public. Keane's good-natured appeal helped open doors. There were community art festivals, hotels, small

galleries and other venues that provided some much-needed exposure. In 1957, for example, the couple had artwork on display at the Washington Square Outdoor Art show in New York and the Mardi Gras in New Orleans, along with brief showings at the Sherman Hotel in Chicago and a small studio in New York on 61st and Madison.

The key was invading each location with a siege-like approach, and using every means available to saturate consumers with information and promotional materials publicizing the paintings. In the introduction to one of Keane's books, writer Richard Nolan described a 1959 trip the Keanes made to New York:

> *For weeks in advance, every public information medium in New York, from the mighty daily newspapers to weekly neighborhood shopping news handbills, were inundated with a flood of graphic material on the Keanes, Margaret and Walter. Hundreds of "opinion makers" were invited to a champagne opening. Three thousand pieces of mail were sent out to prospective art buyers...As D Day approached, the Keanes—including the painting daughters, Susan and Janie...plastered the big city with art posters announcing their coming exhibition; appeared as guests on Dave Garroway's NBC television show; garnered unprecedented space in the metropolitan press...The opening was a mob scene. In the days that followed, every Keane canvas on the walls was sold...The paintings of the senior Keanes brought prices ranging from $600 to $1,500. And they left with the art-buying public crying for more.*[57]

Keane's skill at cultivating journalists also started to pay off. Margaret and Walter began appearing in the local press and some of the major newspapers. However, these short articles were markedly different from the later coverage that focused mainly on Walter and his waifs. These pieces were mainly of the human interest variety, and tended to depict the Keanes as an endearing couple who both painted while trying to raise two daughters. Walter mostly did all of the talking, and presented himself as an altogether different artist in those early years. In his autobiography he bragged that his waif paintings had already earned him a certain amount of fame in Europe, but in his first interviews he made no mention of his supposed overseas successes.

A friendly UPI article that profiled the couple in September 1957 remarked that "Keane does landscapes. His wife is a portrait painter." The reporter noted, "They combine their talents to produce 'symbiotic' paintings with Keane doing the scenes and his wife the figures."[58] Another piece that appeared in the *Village Voice* that same year noted that Margaret often influenced her husband's painting style. "When I paint people," Walter told the *Voice*, "she usually complains that the eyes aren't big enough and proceeds to make them bigger."[59]

In 1958, Keane pulled off a brilliant coup and arranged to hang Margaret's paintings at the hungry i (the "i" stood for id), one of the hottest attractions in North Beach. Known for its three-sided stage and brick wall background, the club was owned by Enrico Banducci, a beret-wearing former concert violinist with a knack for spotting the next big thing. Banducci's establishment offered nightly entertainment along with espresso, wine, and sandwiches. During its heyday in the '50s and '60s, the club became a world-famous proving ground for stand-up comics, singers, and folk groups. Bill Cosby, Lenny Bruce, and the Kingston Trio were just a few of the highly successful acts who got their start at the hungry i.

49

The nightclub's clientele began to include Hollywood celebrities and local politicians. So paying Banducci to hang some of Margaret's art inside the club offered the perfect opportunity to sell paintings and possibly snag a few celebrity admirers. Keane struck a financial arrangement with Banducci, who would allow him to hang the paintings in exchange for a monthly fee. The arrangement worked well, at least in the beginning. But it wasn't long before the two strong personalities clashed. Banducci was known for his no-nonsense persona and had a reputation for ejecting hecklers and permanently banning them from the hungry i.

One night, on March 11, 1958 to be exact, Keane agreed to meet a female friend, Nadine, at Julie's, the bar above the hungry i, for a drink. As the two chatted, they encountered Sue Stanley, Banducci's then-girlfriend, and offered to sit with her. The hungry i owner arrived shortly afterward, and the exact story of what happened next will likely never be known. In his autobiography Keane said that Banducci angrily confronted him, yelling "You bastard! Trying to pick up my woman, huh?" and then took a wild swing at him.[60] The hungry i owner would later tell the newspapers he took a swipe at Keane because the painter was using foul language in front of women.

Keane ducked Banducci's blow, but it struck Nadine, knocking her unconscious. However, it was Keane, not Banducci, who was arrested for the assault. The following day, the *San Francisco Chronicle* carried the lurid headline "Artist Beats up Woman in Bar." In dramatic fashion, Walter and Margaret angrily took down the Big Eye paintings from the walls of the club. A few months later, in a well-publicized trial, Walter was acquitted, and he later blamed his prosecution on a sinister conspiracy involving Banducci, whom he said hoped to generate publicity for the hungry i in collaboration with corrupt prosecutors. It seems likely that Keane's drinking played a role in the altercation. But for Keane, no publicity was bad publicity.

Walter's reputation as the flamboyant, hard-drinking painter

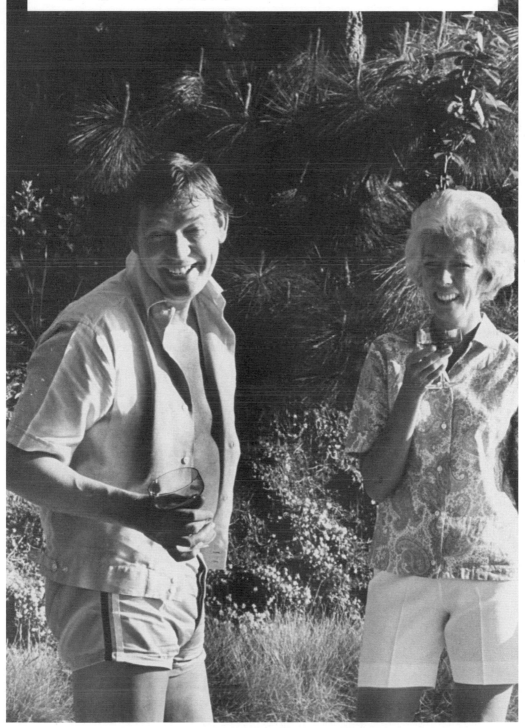

The seemingly happy but recently separated Walter and Margaret Keane in their Woodside backyard near to San Francisco, New Year's Day, January 1965.

Photo by Bill Ray/Time Life Pictures/Getty Images

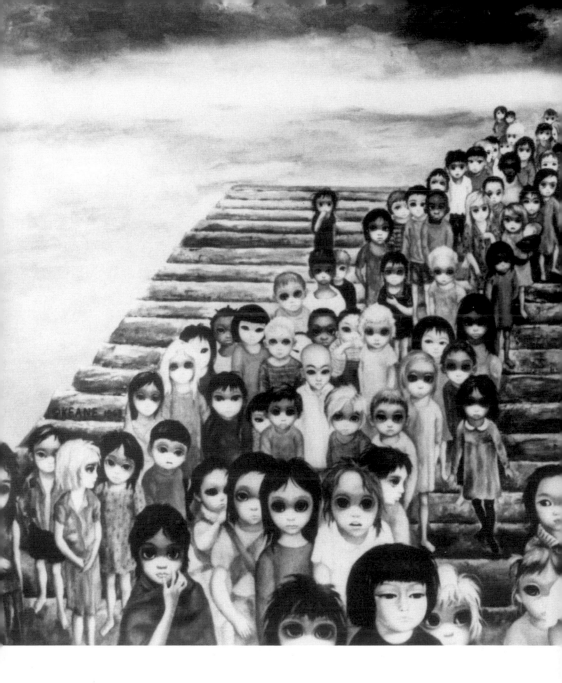

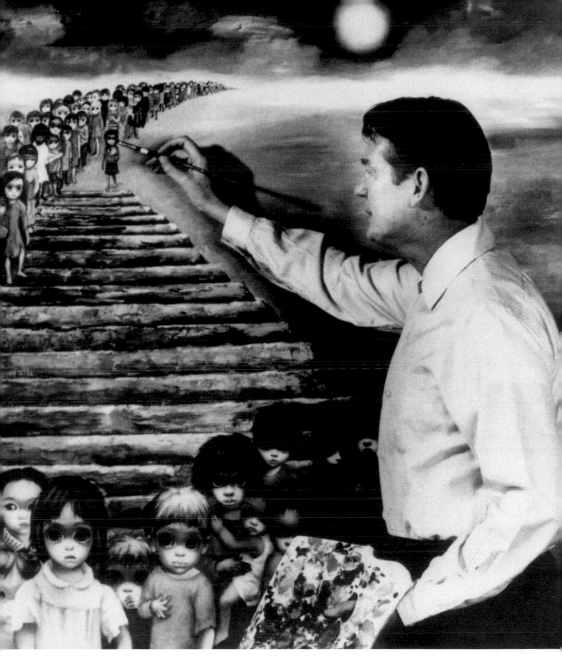

Walter Keane poses with palette and brush to take credit for Margaret's still incomplete painting, "Tomorrow Forever," chosen to be displayed at the 1964 World's Fair' Hall of Education, and later taken down by New York's City Parks Commissioner Robert Moses and ridiculed by New York Times art critic John Canaday as "the very definition of tasteless hack work."

Photo by UPI, 1964.

53

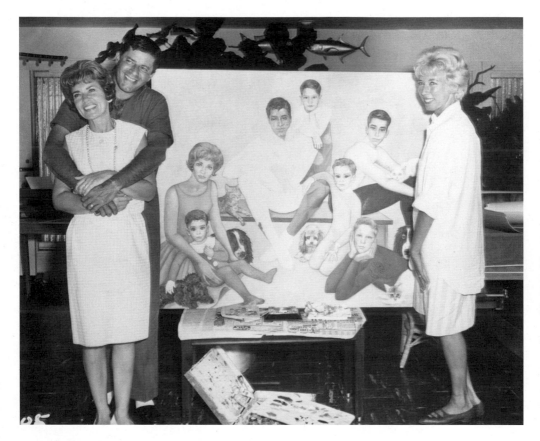

Margaret Keane's still incomplete Jerry Lewis
family portrait with Jerry and his wife Patti. (UPI,
9/10/62) Harlequin wardrobe and infant child add-
ed on to updated version, seen right.

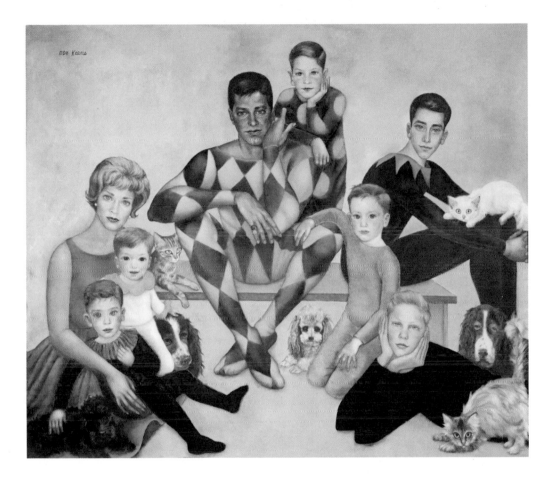

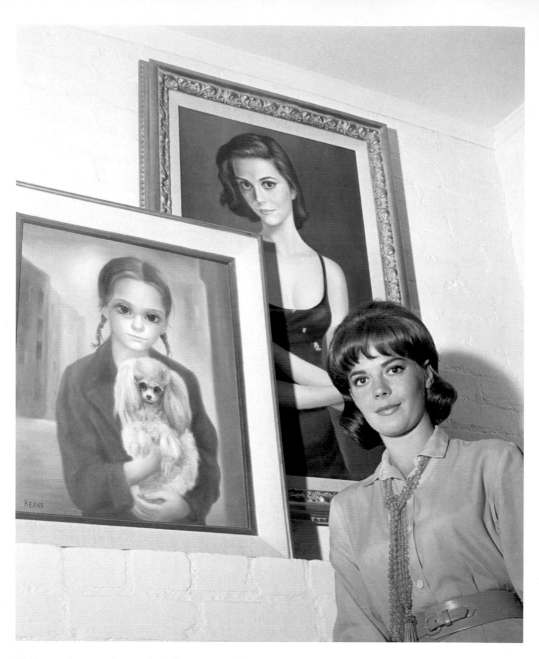

Hollywood star Natalie Wood poses with two Keane portraits, the young, waifish version was said to have been painted by Walter, and the elder Natalie was portrayed as Margaret's own. But the reality was that Margaret painted both.

(UPI, 11/18/61)

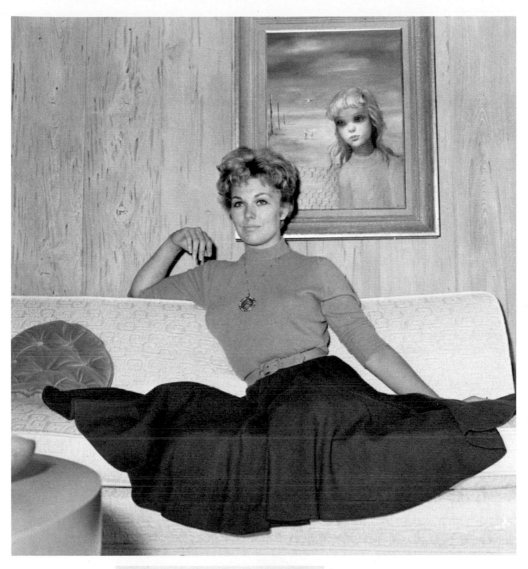

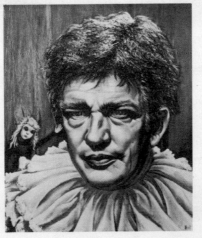

Hollywood siren Kim Novak sits in front of her waifish self, claimed to have been painted by Walter Keane. Novak returned the favor by painting Walter Keane in a ruffled collar and a little girl poking his ear.

THE

VIGILANTE

SUMMER 1960
PRICE 50¢

KEANE

The Vigilante, a San Francisco-based tourist guidebook from Summer 1960 bears a Margaret Keane portrait of Chinatown and a young resident (left), and from the interior of the magazine, Walter Keane poses at the Black Sheep Speakeasy bar as he gets familiar with a sheep and two young cuties.

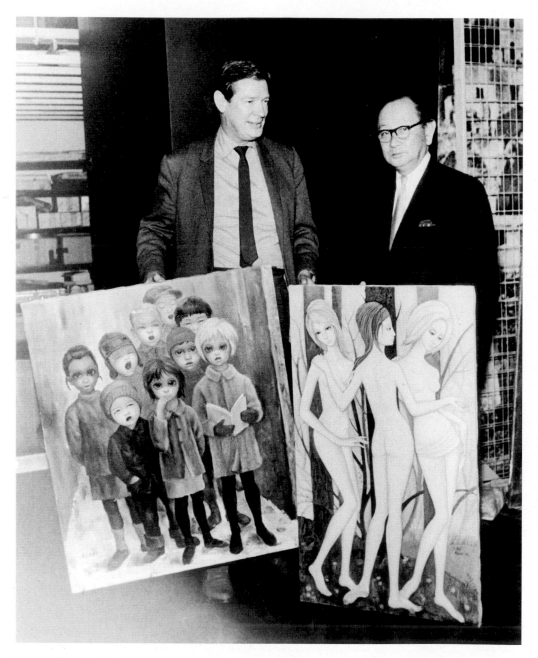

Walter Keane with Dr. Soichi Tominga, director of the National Museum of Western Art in Tokyo, with two Keane paintings acquired by the museum for its permanent collection alongside work by Renoir, Degas, Gauguin and Pissarro. (Associated Press photo, May 2, 1964)

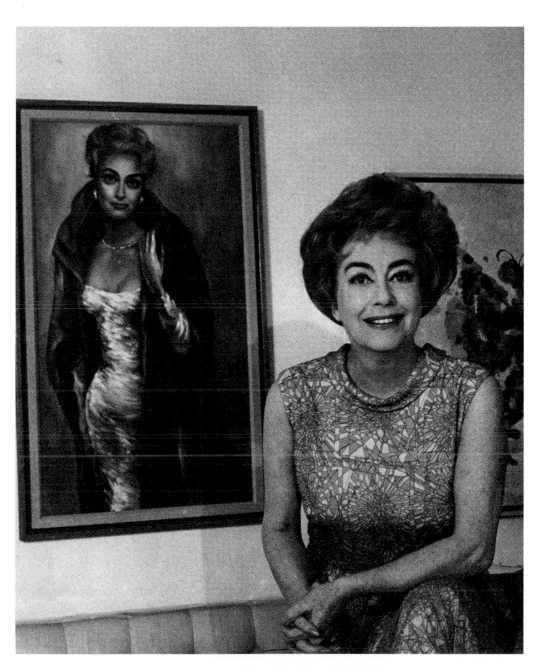

Joan Crawford and her beloved Keane portrait, as shown in
her autobiography, *My Way of Life.*

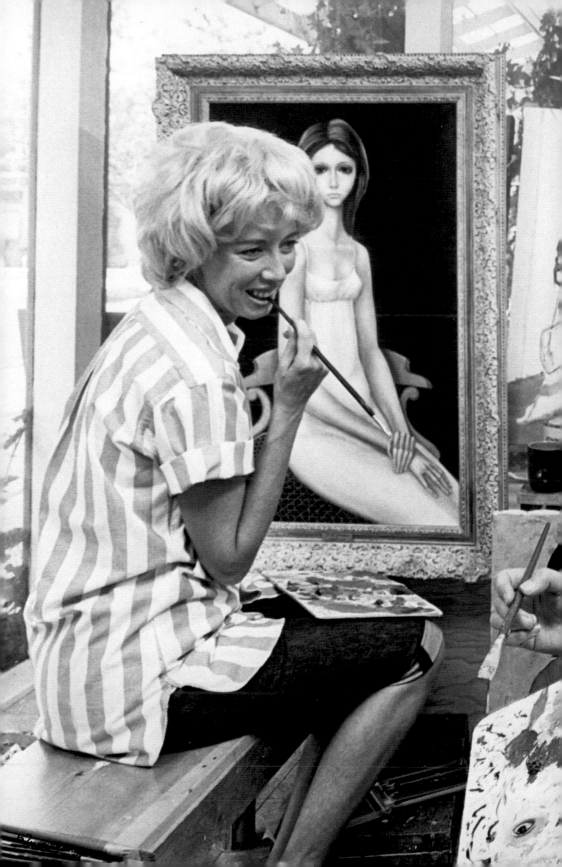

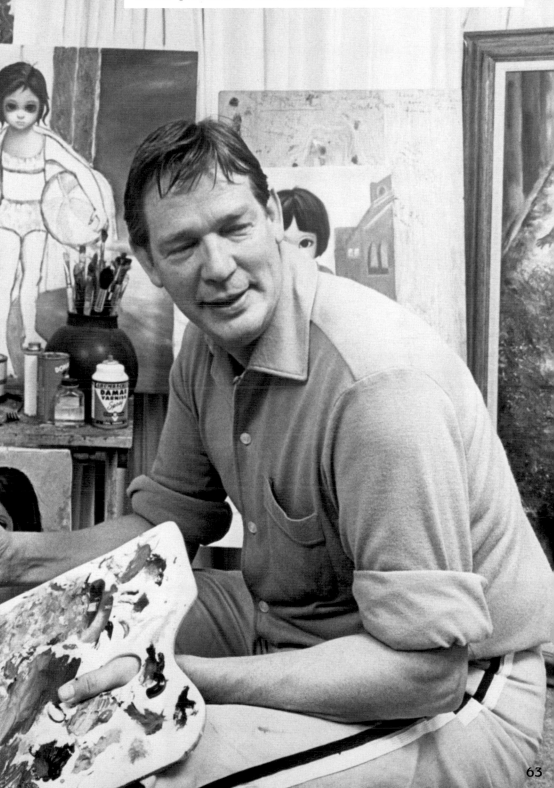

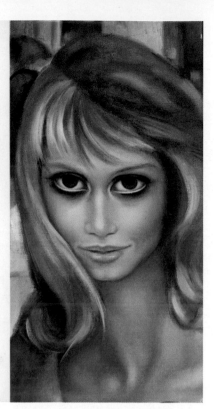

MDH

MARGARET

KEANE

Foreword By
Elton Fiscus-Powell

TOMORROW'S MASTERS SERIES
Johnson Meyers

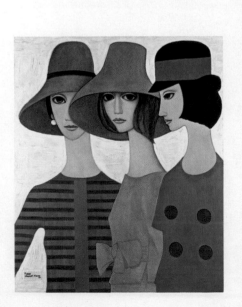

Front and back covers of Margaret and Walter Keane's slipcased double edition of their painting examples. Johnson Meyers, 1964.

The World of
KEANE

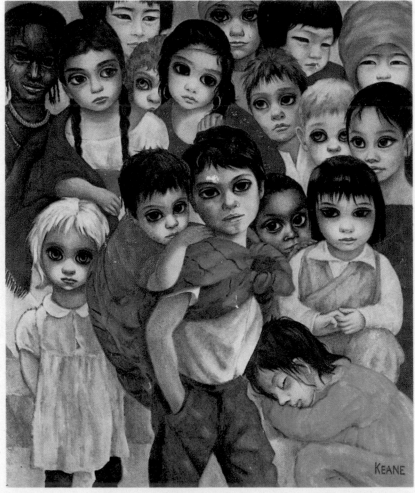

THIRTY-TWO PAINTINGS AND DRAWINGS
by Walter Keane

Walter Keane's sad swan song arguing his artistically brilliant work and life.

"We paint truth and emotion..."

Margaret and Walter Keane

TOMORROW'S
MASTERS
SERIES

TEXT BY
RICHARD
NOLAN

Cover for an early paperback edition release of
Margaret and Walter's "togetherness" art.

Walter and Margaret dab at their canvases. UPI's caption continues the façade of Walter the painter: "Busy capturing their different images of Natalie Wood on canvas, artists Walter and Margaret Keane work side by side in the actress' Bel Air, California home. The husband-wife team comes from San Francisco. 11/18/61, UPI

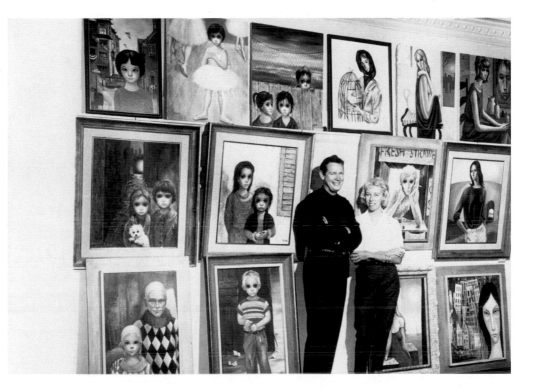

From UPI's 8/3/60 caption: "Painters in art as well as matrimony, Margaret and Walter Keane show off the paintings they'll take from their native San Francisco Calif., to Japan. Walter's works are on the left, his wife's on the right. The Keanes, who have staged many art exhibitions in the U.S. and Europe, will be making their first visit to the orient aboard Japan Air Lines inaugural flight on August 12th."

From UPI's 7/5/57 caption: "With a whole family supply of art to carry around, the Keanes' small foreign car sees plenty of use. The opening in the roof is handy for the long, narrow pictures. The Keane paintings are on display in many galleries throughout the U.S. and in Honolulu, as well as in one San Francisco restaurant which has trouble keeping them on the walls because of the demand."

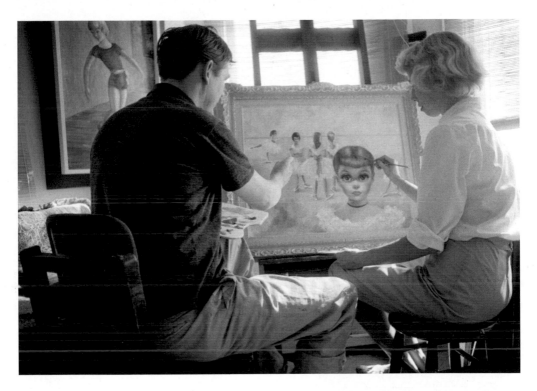

The strange UPI caption from 7/5/57 notes in a nearly straight-faced manner: "In a unique example of togetherness, Walter and Margaret put the finishing touches on a joint effort which has already been framed. They frequently pool talents on one canvas, effecting an unusual combination that makes their paintings much in demand."

Walter Keane doesn't appear for this paint-off in San Francisco's Union Square for *Life* magazine's camera.

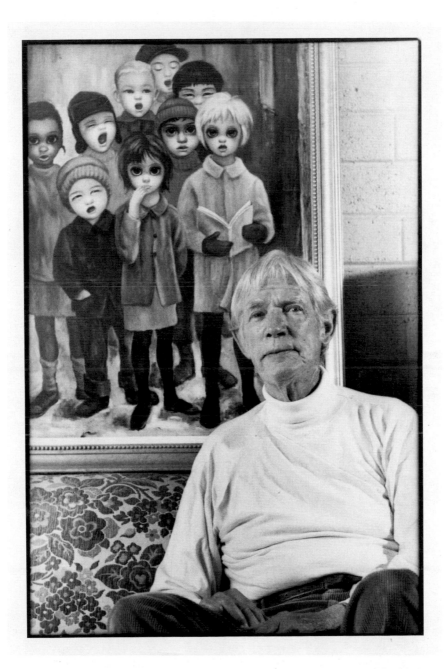

After losing every single trial, Walter Keane sits in front of a framed lithograph
of his contested artwork in his LaJolla bungalow, 1989.

Photograph by Scott Lindgren.

Margaret Keane painting given by Walter to "supporters" and "buddies" at United Press International.

would keep his name in the newspapers for weeks, and sales of the waif paintings began to surge. The incident at the hungry i also gave Keane the incentive to take the next step and rent his own gallery. In March 1958, the Keane Gallery at 494 Broadway opened its doors.

Apparently Keane discovered the public's fascination with Margaret's Big Eye style almost by accident. Armed with ladders and staple guns, Walter and a few associates nailed a series of posters publicizing the new gallery to telephone poles, buildings, and fences throughout North Beach and San Francisco. The posters featured reproductions of some of Margaret's early waif sketches and paintings. They were an instant hit.

"They'd be torn down hours after we put them up," Walter later remembered. "People kept pouring in asking how much the posters cost! We started handing them out for free, but after a while we couldn't afford to keep that up. First we charged a dollar for them, and then two, and then we just sort of caught on all over."[61]

75

Keane would later learn that many of the posters were being framed, and had a moment of inspiration. "I reasoned," he recalled in his autobiography, "that there must be a market for prints of my paintings. Thus the idea of lithographs of my lost children was conceived." Margaret offered a similar account when she told the couple's story before an audience at Stanford University in 1964. "The Keane posters kept disappearing," she explained, "until one day the snatchers came to the gallery asking for clean editions. It was then that Walter Keane decided to charge a small price for the product. This was the beginning of the Keane lithograph phenomena."[62]

Walter made arrangements with a local printer (he would later have the prints made by a Japanese firm) to produce lithographs of Margaret's paintings and make her artwork affordable to the general public. Paul Nelson also began showcasing the art and selling prints at colleges in the Midwest, building a substantial following for the Keanes. Every year, additional paintings were

added to the Keane lithograph collection and the mass-marketed prints would soon bring in millions.

As the Big Eye posters went viral, they became a common sight among hip young apartment dwellers throughout the Bay Area. The Keane Gallery was beginning to attract attention, and its location played no small role in Walter and Margaret's subsequent success. "Once he opened up the studio next to Vanessi's, that was the catalyst," recalls Bob Miller. Located at 498 Broadway, Vanessi's was a popular Italian restaurant known for specialties like chicken cacciatore and spaghetti carbonara. At the time, the restaurant was a preferred spot for some of the Bay Area's more well-heeled diners. The crowds who flocked to Vanessi's couldn't help but notice the Keane Gallery, and Walter wasn't exactly easy to ignore.

"He was a unique individual," Miller remembers. "He was sort of Mr. North Beach. He kind of owned the area." And he recalls that Keane had a good-natured flirtatious side that never failed to charm the ladies. "He could say things and get away with things that if you and I ever tried them we'd get a slap in the face," he says.

In his memoirs, Keane fondly recalled getting the royal treatment at the popular restaurant. The maitre d' would escort him to his favorite table, which would be all set up with a bottle of fine wine in a bucket of ice. His usual Chivas Regal would be served to him in a long-stemmed wine glass and the head chef would often prepare a unique and special meal for the gallery owner and any of his guests.

The fun-loving Keane was in his element, and back then North Beach was a drinker's paradise. Even long before he gained notoriety as a painter, Walter's reputation as a boozer was well established. There is little doubt that Keane could be charming, irreverent, and fun to be around, but like many heavy drinkers, when he was on a serious jag a darker, less endearing side came to the surface. Dick Boyd, who was a co-owner of Pierre's at 546 Broadway,

doesn't have fond memories of encountering Keane when he was on a tear. Boyd recalls Keane vividly in his *Broadway North Beach–The Golden Years: A Saloon Keeper's Tales* (Cape Foundation Publications, 2006):

> *...his studio was on Broadway upstairs of Vanessi's. Since we now know that his wife Margaret did the featured eyes in the paintings, it could explain how Walter had so much time to drink. It may also explain why he was such an angry drinker. When he was drinking he became argumentative and used the vernacular of a longshoreman. It didn't matter who was around when he was drinking, he had a nasty mouth...* [63]

"Walter was a binge drinker in my opinion," Boyd wrote in an e-mail to the authors. "Sometimes we would not see him for a long time. That was usually when he was traveling. I think when he was in town was his time to play." And apparently Keane's booze-fueled antics were well known to various North Beach bar owners. "Owners and bartenders were aware of his behavior when he was drunk," Boyd remembered. "We just dealt with it if he was spending unless he was annoying other customers. Then we either cut him off or asked him to leave or both."

Apparently Keane also loved to play liar's dice, a bar game akin to poker. He often played the game with Tommy Vasu, a.k.a. "Tommy the Dyke." Vasu, a legend in North Beach's gay and lesbian community, liked to wear double-breasted suits and a fedora, and owned a stake in Tommy's Joint, a popular lesbian bar at 529 Broadway—making her the first out lesbian to enjoy legal ownership of a drinking establishment. She was also something of a gambler and never tired of

taking Walter's money. The games between the two would start at $20 (a significant sum in the '50s) and often go into the hundreds.

Vasu wasn't Walter's only opponent, and his luck didn't fare much better with other players. "Keane was a lousy liar's dice player and almost always lost," Boyd recalled. But Keane could be a sore loser and wasn't above accusing people of cheating. There were some rough characters in North Beach, and sometimes the accusation wasn't taken lightly. After a few ugly incidents, he even briefly hired Eddie Ascencio, a notorious local skull-basher, to follow him on his drinking sprees and act as his bodyguard.

If Keane sometimes overdid it and got into the occasional scrape, he had nothing but fond memories of his early years in North Beach in his autobiography. "North Beach was an artist's paradise in those wonderful days," he wrote. "Jack Kerouac, William Saroyan, Bob Scobeys [sic], Bert Bales and many unconventional individuals. They were all friends. I drank with them on many occasions and had some of the really good times in my life."[64]

According to Keane's memoirs, Kerouac was an old drinking buddy from way back. "Whenever he saw me coming into one of our favorite bars," he recalled, "he would yell a standard invitation to his friends by way of greeting me, 'Come on in and get drunk, all work and no play make Walter a dull boy.'"[65] Keane claims that the night he first met Margaret, the couple ran into Kerouac coming out of City Lights, poet Lawrence Ferlinghetti's influential North Beach bookstore.

If the Keanes were enjoying their first taste of success and appeared to be one big happy family when the newspapers called, the reality was far different. Margaret would later say that from the outset, she began painting her wistful, sad-eyed waifs as a reflection of her growing unhappiness. "In the beginning, I didn't know why I did them," she told the *New York Times* in 1992. "They all have these large eyes. I was painting my own inner feelings. I was very sad and very confused about why there was so much sadness in the world

and why God permitted wickedness."[66]

Despite Walter's claims of painting his first waifs while overseas, Margaret has insisted that she'd been doing Big Eye drawings and sketches for most of her life. "I always enjoyed doing faces. I used to scribble and doodle in my textbooks in the margins. Scribbling and drawing all the time. [I] used to always draw faces," she recalled in an interview.[67]

Margaret usually signed her paintings "Keane"—her married name. When Walter claimed them as his own work, he was off and running. After Margaret found out that Walter was posing as the artist and confronted him, Walter told her it was a sales gimmick that pleased customers. "When I asked him why he said he was the painter," she explained in a 1970 UPI article, "he said the buyers always wanted to pay more if they met the painter."[68] Walter had created an entire persona around the waif paintings that couldn't easily be retracted.

"The whole thing just snowballed and it was too late to say it wasn't him who painted them," Margaret told the *Times*. "I'll always regret that I wasn't strong enough to stand up for my rights."[69]

Margaret had also learned that Walter, who claimed that he painted sophisticated Paris street scenes, hadn't been honest about his actual talent. "He kept saying he was rusty, he hadn't painted in a long time," she said. "So I thought he was rusty and he would soon get back into painting to the level of the street scenes."[70] Then she made a startling discovery. "We were married about two years and I came across this big box in the back of the closet one night when he was at the hungry i selling paintings," she recalled, "and I opened it up and there were all these street scenes, about ten of them, just like the ones he'd been selling. Only these were signed S-E-N-I-C. As soon as I saw these I knew he hadn't done the other ones."[71]

When she raised the issue with Walter, he claimed that the paintings were the work of his art teacher. He assured her that the street scenes signed with his name were actually his work. Margaret didn't

79

believe him. "I knew he didn't [paint the street scenes]," she said. "From then on I knew the truth, but he'd kept saying he'd learn to paint if I could help him, teach him. And when he couldn't paint he'd say it was my fault, practically had me convinced it was my fault he couldn't paint. If you can believe that! He just drilled it into me constantly: it was my fault he couldn't paint."[72] She did later concede that her ex-husband "sometimes put a little paint on the backgrounds" and he "also had a good color sense, helping me pick out colors one time."[73]

If Walter often pleaded with Margaret to let him continue posing as the creator of her sad-eyed waifs, she claims he was not above making threats if she thought of exposing his ongoing sham. "He was threatening to kill me and my daughter," Margaret remembered. "I was really very much afraid of him."[74] Miserable and fearing for her life, Margaret tried to make the best of a bad situation. She allowed Walter to gain acclaim while she ran the household, painted the Big Eye waifs, and in what little spare time she had, painted a series of mysterious adolescent women in a style akin to Modigliani, in the hopes of carving out her own artistic identity. If she was amazed by the Keanes' artistic success, money did not bring happiness. "After we started to make it," she recalled, "it didn't make any difference. All I got out of it was a larger house to keep."[75]

Meanwhile, New York was reluctantly taking notice of Keane's growing popularity. As the price for a Big Eye original surged into four figures and crowds began flocking to the North Beach gallery, Walter shrewdly opened another location in New York. The initial reaction was far from positive. "I stumbled across an exhibition by Walter and Margaret Keane in their own gallery at 798 Madison Avenue," wrote *New York Times* art critic Brian O'Doherty in 1961. "I stumbled out again, and mention the encounter only to draw attention to what is a classic example of non-art. Mr. and Mrs. Keane have one pathetic gimmick. They enlarge all the eyes in their paintings. Neither Mr., and Mrs. Keane, nor the eyes, have it."[76]

Aside from critical hate, the Keanes were on the cusp of monumental success, and the curtain was falling quickly on Abstract Expressionism as the country's prevailing artistic movement. Pop Art, Funk Art, and a variety of irreverent, playful and innovative painting styles were beginning to attract attention. If Keane paintings weren't officially recognized as Pop Art, the waifs certainly had a certain unique appeal that was widely popular with the postwar art-buying public. Walter had shrewdly turned his back on the avant-garde and thrown his lot in with the masses, and what had started as a small, grassroots phenomenon was about to explode nationally.

Big Eyes would soon become an empire. New York's disdain, if not outright hostility, toward the Keanes was destined to only accelerate with time. But it really didn't matter. The public was falling in love with the Keane waifs.

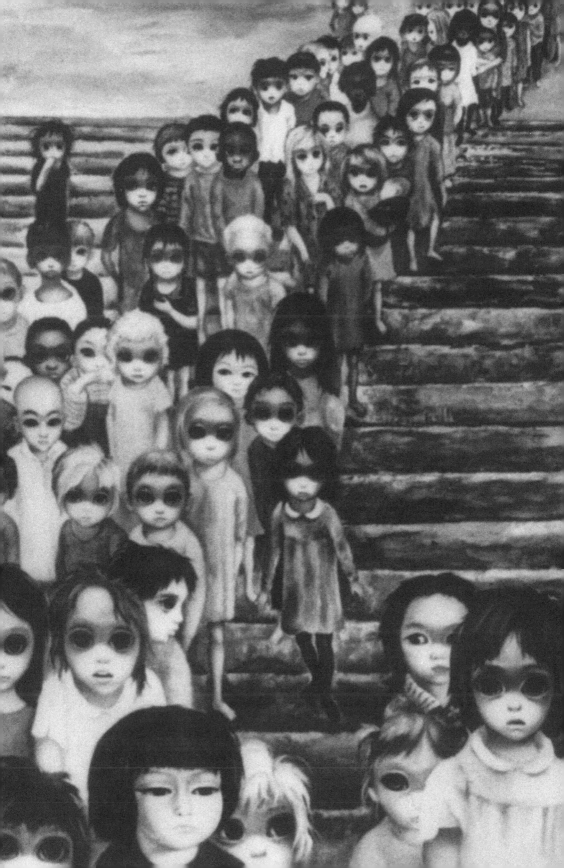

Waif World: Big Eyes, Big Money

In 1954, two years before his tragic death in an automobile accident, abstract artist Jackson Pollock sold a painting to Ben Heller, a New York collector, for $8,000.[77] At the time Pollock was considered one of the country's finest modernist painters. Heller's purchase would end up being the most lucrative sale of Pollock's career. Fast-forward a few years, and Margaret and Walter Keane, outsiders with practically no critical support, were pocketing checks for that amount and more for original paintings. If they weren't revered by the East Coast art establishment like Pollock was, they'd won the hearts and minds of suburbia, and Hollywood.

83

And the Keane galleries in New York and North Beach weren't the only way to cash in on the Big Eye craze. There were prints, postcards, and other Big Eye bric-a-brac that generated millions in additional revenue. If the husband-and-wife team didn't get the respect they felt they deserved, few could deny their success. On a busy day, the Keane Gallery in North Beach would often draw over a thousand visitors in just a few hours.[78]

The Keanes were moving up in the world and they started living like celebrity artists. In the early 1960s, the couple and their two daughters, Susan and Jane, moved to Woodside, California, a small scenic town thirty miles south of San Francisco. Known for its towering redwoods, ocean views, and gorgeous mountain vistas, today

Woodside is considered one of the priciest zip codes in the country. Homes often run into the tens of millions, and because the town was zoned in 1956 to curb overdevelopment, the few available vacant lots will sometimes go for a cool million or more.

The eleven-mile slice of real estate is now home to wealthy Silicon Valley executives, Hollywood celebrities, and music legends like Neil Young and Joan Baez. Back then, Woodside had a reputation as a beautiful upscale suburb that often drew landscape painters who reveled in the town's breathtaking scenery. The Keanes moved into a secluded two-acre bungalow with a kidney-shaped pool in the backyard, and bought four poodles, which they named Rembrandt, Gauguin, Degas, and Matisse.

It was idyllic—at least for Walter. When he wasn't enjoying his pleasant new surroundings, he was likely zipping up to North Beach in a Cadillac to hit some of his favorite watering holes and chatting on his car phone with politicians, movie stars, business partners, and more than a few starstruck female admirers. And Keane loved to travel. He'd taken trips to Spain, Japan, and, emulating Gauguin, even the South Seas. And at every stop, there was fun to be had. Even decades later, Walter could barely conceal a roguish grin when asked what it was like during his glory years. "Oh yes," he remembered, flashing back to his heyday, there was "womanizing, traipsing around Europe, boozing it up, fame, money...God what a life."[79]

At least he was having a good time. Margaret wasn't doing much high living. At the time the Keanes would tell reporters that the only way they could find precious time at the easel was to work between midnight and five a.m. There are press photos from that era that depict the couple toiling away side-by-side. To hear Walter tell it, the couple's artistic success would never have happened without endless hours of hard work and dedication. "Art is like anything else," he explained in a 1962 interview with the *Los Angeles Times*, "you have to do it every day, not sit around thinking about it."[80]

If Margaret admired her husband's abilities as a master promoter, she couldn't help but resent the unequal division of labor when it came to the actual painting. "I did the paintings," Margaret would later say. "He was the one who promoted the paintings and sold them. I can paint and he can't."[81] So Margaret juggled her household and parental responsibilities and painted into the wee hours. She also held on to Walter's deep dark secret. And her husband took desperate precautions to make sure no one knew his wife was painting the waifs.

"I'd have to lock the door of the paint room," Margaret told the *New York Times* in 1999. "He wouldn't allow anyone in. I was like a prisoner."[82] She was still trying to create her own artistic identity, so she worked on the Big Eye paintings and adolescent women simultaneously. All together, she created somewhere between fifty and sixty paintings a year.

The dizzying pace was taking a serious toll, and if that wasn't bad enough, she suffered through interviews with the press and nodded approvingly while Walter expounded on *his* artistic struggles and the inspiration behind *his* waifs. It seems amazing in retrospect that she was able to hold her silence. With each success, her husband only seemed to grow more grandiose in his role as the sham virtuoso.

Some addiction experts believe there is a link between egomania and alcoholism. If Walter didn't seem to harbor much of a messiah complex when he was a Berkeley real estate salesman, once he assumed his new identity as painter of the world's lost children and began tasting success, his sense of self-importance ballooned. As his name began appearing in the papers on a regular basis, he started talking about himself in the third person, likening himself to revered painters such as Gauguin and El Greco. In Walter's eyes, the paintings themselves also began to take on greater importance.

Walter believed that the waifs weren't just a joy to look at, the children were also powerful symbols of what was wrong with the world.

85

If people would just *look* at the waifs, *immerse* themselves in those sad, haunting eyes, they'd get the message. As he would later write, "I wanted to remind them that the future lies in the lives and faces of those children...I felt a sense of mission for world peace."[83] Keane seemed to think the paintings would do for the world's starving and abused children what Picasso's *Guernica* did to reveal the horrors of modern war.

Whether this was Walter's influence, or Margaret shared his high-minded ideals, the paintings began to take on a more universal message, uniting children of different ethnic backgrounds. *Peace on Earth* (1961) has a multiracial cast of children who are depicted singing Christmas carols. The colorful sweaters of the singing waifs contrast harshly with a dark, grayish background that gives the viewer the impression that the unhappy tots are singing in some impoverished urban setting. A similarly themed painting completed that same year, *Our Children*, was a particular favorite of Walter's (the painting appears on the cover of his memoirs).

"The canvas," Keane recalled in his autobiography, "was painted with a burning hope of the artist: that these youngsters of the world might look down from a wall of the conference room at the summit meeting of the world powers so that the heads of state and leaders gathered there to debate peace and war would be reminded for whom they are deliberating."[84]

The painting was purchased by the Prescolite Manufacturing Corporation and donated to the United Nations Children's Fund on August 30, 1961. The 3 x 4 canvas featured another multicultural cast of somber-faced children, jammed together in a claustrophobic freeze-frame. The sad-eyed figures, some dressed in the garb of their respective countries, are oddly reminiscent of the children featured in the "It's a Small World" attraction at Disneyland (which would debut three years later at the New York World's Fair).

86

The unveiling of the painting included a star-studded celebrity gala and landed Keane on the *Jack Paar Show*, where Walter enjoyed the gushing praise of his network host. According to Keane's memoirs, Paar "talked for several minutes uninterrupted," saying *Our Children* "is the greatest painting he had ever seen." It was left to Paar's modest guest to give the host a bit of perspective. "I whispered to Jack," Keane wrote, "There's Rembrandt, Vermeer, and Degas."[85]

A few months after *Our Children* was unveiled, the Cuban Missile Crisis brought the United States and the Soviet Union to the brink of nuclear war. It was a time of nail-biting tension between the two global superpowers, and the threat of a Soviet nuclear attack seemed all too real to many Americans. Walter felt it was time to act. "With the Cold War at its height," he later wrote, "I knew the importance of improving relations with the Soviet Union."[86] Could Big Eye art succeed where public diplomacy had failed? Walter was determined to find out.

As far back as 1958, the Keanes had repeatedly attempted to obtain the necessary visas to exhibit Big Eye art in the Soviet Union. Walter already had an itinerary that would involve exhibitions in all the major Russian cities and, in an act of goodwill, he planned to purchase art from some of the country's leading artists so their work might be shown in the United States. The pair had even solicited the help of California Senator William F. Knowland (a "longtime friend") to assist them with their diplomatic venture.

Keane alleged in his autobiography that he traveled to Washington, D.C., where he and Knowland met with officials from the Soviet embassy. While the meeting may have been cordial, the proposed trip never got off the ground. According to Keane, sometime later he received a call from an unknown official from the Soviet embassy in Washington D.C., who told him his planned visit wasn't going to happen. Apparently someone in the upper echelons of the Soviet government feared the waifs would cause unrest. "We have a directive from

Moscow," explained the Soviet official, "stating that our government feels you would make trouble for the Russian people."[87]

It's difficult to verify whether or not this conversation occurred. The authors filed a Freedom of Information Act request with the U.S. State Department and received two documents pertaining to the proposed visit. One was a 1958 letter from Knowland requesting that the State Department approve a visa for Margaret and Walter to visit the Soviet Union, and another was a document from May 26, 1965 with a one-paragraph mention of the Keanes. The memo states that a Mr. Bugrov, the Cultural Counselor at the Soviet embassy, was given two books containing various Keane paintings and a request to show several of their paintings in Moscow. Apparently Bugrov examined the books and promised he would forward them to the Ministry of Culture or the Artists Union for consideration.

Perhaps this may have led to the terse telephone exchange Keane recalled. Then again, it's just as plausible that Bugrov was simply being polite and had no intention of passing along the information. As there were no other State Department documents related to the proposed tour, it seems likely that the visit never materialized because of bureaucratic inertia rather than Soviet fears of political subversion. It might be worth speculating that Walter added the telephone conversation with the mysterious Soviet official to give an element of cloak-and-dagger drama to an otherwise uninteresting story.

The success of *Our Children* would lead to a similar work three years later, a waif-packed wall-sized painting that would further inflame Walter's mind with dreams of artistic immortality. If there is one recurring theme in Walter's memoirs, it is his frequent insistence that *Tomorrow Forever* is the finest of all the waif paintings—on par with some of the Western world's great works of art (more about that later). He even dedicated an entire section of his autobiography ("The Masterwork") to the painting and how it came into being. It's certainly

the most ambitious of the Big Eye paintings. Like the illustration of the marching Chinamen seen in *Ripley's Believe It Or Not* syndicated books, the oversized painting depicts a horizon of endless Big Eye waifs.

In one of the most bizarre scenes in his memoirs, after supposedly completing his visionary painting, Keane's deceased grandmother "appears" to him and speaks:

> *My Little Walter, we have seen your masterwork. Please tell us in your own words what was in your mind and in your heart when you created* Tomorrow Forever.

> *"I will try Grandmother." My mind reaching back into many yesteryears, I began.*

The memoir suddenly takes flight with a mythopoeic sermon on the painting's evolution, from initial sketches to the completed "masterwork."

> *Over the horizon of the infinite past—out of the ages lost even to the pin-pointers of time— they come, as they must have been coming in my unconscious ever since that deeply etched day in Berlin.*

> *They come in multiplying numbers from the first moment of creation, down to the moment that is now—a moment that is a restless fraction of eternity—a moment that must move on into tomorrow, on into tomorrow's tomorrow, and the tomorrow of that morrow, on into tomorrows forever.*

But they are only children! No, not children: mankind. For the child, in the words of Wordsworth, is father of the man. Somewhere in unrecorded time, eons before the earliest civilization, a man planted a seed that became one of these children, and that man owed his being to a seed planted eons before him. The timeless river of Life; or, in Kahlil Gibran's phrase, Life's longing for itself.

They stand witness that this longing will not be denied, for they journeyed down to the moment that is now through glacial waste and deluge, through plagues on end; yea, through the most devastating of all malevolent forces, man's own evil.

Blessed with a fiber so sturdy—and midway in the passage toward another tomorrow—they should be full of scamper and laughter, as were those children who were their ancestors. Yet their eyes, eyes that reflect the ecumenical soul—hold an arresting gravity: a wonder but an ominous wonder; not the innocent, enviable wonder that is the heritage of childhood. Their eyes, so somber and unblinking, may seem to accuse; but no, the case penetrates deeper. Their eyes speak a query—a query all the more unmistakable for its weighty silence: What are the bequeathers of their tomorrow up to?

Studying the faces of these children—that one on the right, has he not the features of tomorrow's Gandhi? And this one, the look of Moses? Over there, another Socrates? And here, Maimonides? Those others—a Galileo?...a Linnaeus?...A Pasteur?

Who is that? Caesar? No, the shadow passes; an illusion only. For these children— the children of today's universe—given the right response to their mute query, will reclaim their heritage and start scampering toward "Tomorrow Forever."[88]

Walter's ectoplasmic Grandma rejoices at the lofty description of *Tomorrow Forever* and crows:

At our last meeting of the artists', writers', painters', and poets' group, Michelangelo put your name up for nomination as a member of our inner circle, saying that your masterwork Tomorrow Forever *will live in the hearts and minds of men as has his work on the Sistine Chapel. You were honored by the unanimous vote of all our members and you will official- ly join us in the year 2007. This is just the beginning.*[89]

Accolades continue to pour in from the angelic afterlife. A spir- it (with an apparent background in art criticism) named "Bernard" chimes in with more effusive praise and compares Walter to Leonardo, Raphael, Tiepolo, and Veronese:

With Tomorrow Forever *Keane reach-*
es such an extraordinary level of achievement
that the mind boggles at the thought that this
still young artist has within him the potential
to achieve even greater levels. Yet regardless of
what he accomplishes in the future, the impor-
tance of Keane will remain clear in the light of
the vocabulary of forms and emotive images he
has already established for world art.[90]

Walter obviously believed *Tomorrow Forever* was an important painting. If this landmark achievement was getting rave reviews in the strange recesses of his mind, where his deceased grandmother held court with the world's greatest artists, it wouldn't be long before the earthly praise started pouring in.

His hopes were realized when the Big Eye masterpiece was chosen as the theme painting for the Pavilion of the Hall of Education at the 1964 New York World's Fair. When Walter heard the news, he was ecstatic, and would later describe this high honor as the "happiest moment of my professional life."[91] According to a press release that announced the selection, Keane's marching waifs had received stiff competition from a significant number of submissions, but a panel of experts had decided *Tomorrow Forever* was the perfect painting to hang in the pavilion.

The Hall of Education, where the painting would be displayed, was sponsored by an alliance of businesses tied to public education. In keeping with the fair's futuristic theme ("Man's Achievement on a Shrinking Globe in an Expanding Universe"), visitors who strolled through the display were given the opportunity to imagine the American classroom of the future. There was a scale model of a school circa 2000, displays featuring cutting-edge (at least for 1964) audiovisual aids and teaching techniques, and what were then called

electronic teaching machines. The pavilion also included a lecture hall where well-regarded individuals from a variety of professions debated U.S. education policy. There was also a playground and a restaurant. It wasn't exactly the Louvre, but Keane was more than happy to finally get some official recognition.

Besides, you couldn't put a price tag on exposure like that. Fair organizers estimated that over seventy million people would flock to the "universal and international" exposition (although they ended up being disappointed). If even half that number walked through the Hall of Education, sales of Keane paintings, posters, and prints would likely skyrocket and build a substantial market for Big Eye art in the country's most influential art metropolis. Unfortunately, within days of the announcement Keane's joyful moment of recognition turned into a crushing disappointment. The instigator of Walter's downfall was *New York Times* columnist John Canaday.

Canaday was a 55-year-old former art professor and frequent writer of key art reference books who was in his fifth year at the *Times*. At the time, he was considered the leading art critic at the newspaper, and had developed a reputation as a thoughtful and sometimes wickedly sarcastic commentator on the arts.

If he enjoyed an uneasy truce with some of the more renowned abstract artists, he could be caustic and unforgiving about any art he felt reeked of pretense or fakery. "The best Abstract Expressionists are as good as they ever were," he wrote in a controversial column for the paper. "But as for the freaks, the charlatans and the misled who surround this handful of serious and talented artists, let's admit that the nature of Abstract Expressionism allows exceptional tolerance for incompetence and deception."[92]

The column generated hundreds of angry letters and earned him enemies among the city's artists, collectors, and academics. Yet Canaday went on to cultivate a large and dedicated readership, many of whom relied on him to navigate the various modernist currents then

sweeping New York. In 1964, he was at the height of his powers, and when he stumbled upon the press release announcing that *Tomorrow Forever* would be exhibited at the upcoming World's Fair, he was horrified.

"The most grotesque announcement so far from the New York World's Fair comes in the form of a statement from Dr. Nathan Dechter, chairman of the board of directors of something called the Hall of Education," Canaday began in a column that ran on February 21, 1964. "It says, God help us all, that a painting by the 'internationally celebrated American artist, Walter Keane' has been selected by a 'panel of critics' from a 'large number of submissions' as the theme painting of the Pavilion of Education."[93]

As for the artistic merit of *Tomorrow Forever*, the critic didn't mince words. Describing Keane's art as "tasteless hack work," Canaday noted that the selected painting "contains about 100 children and hence is about 100 times as bad as the average Keane." A few phone calls to chairman Dechter further revealed that that the selection process by the so-called "panel of experts" was haphazard at best.

"Actually we didn't invite submissions," Dechter informed Canaday, "We just went around and looked." Canaday asked what Dechter considered fine art. The response: whatever pleases the public. "Something's wrong," Canaday sighed to end the column.[94]

Canaday's wickedly sarcastic article produced an immediate response. Within three days, the painting was swiftly withdrawn. Robert Moses, president of the fair, issued a terse press statement. "The Fair does not censor exhibits," Moses declared, "except in cases of extreme bad taste or low standard. This was such a case."[95]

Canaday's brutal takedown of Keane would be mentioned for years to come. The fact that it came on the heels of a bizarre protest that spoiled Margaret's lecture on "Women and Art" before a female student group at Stanford University only increased Walter's ire. Keane would rally a handful of journalists to respond to the withering attack.

94

"The New Yorkers are having a capital time at Keane's expense," complained Vera Graham of the *San Mateo Times*, in a thousand-word broadside that that ran a few days after the painting was pulled from the exhibit. "And what is the furor about? What kind of painting is it? Its subject is about 100 kids—of all races and nations—spilling forth toward the forefront of the canvas in an endless stream of children extending from the horizon." The real villains, according to Graham, were the "erudite gentlemen" and their "true-art sycophants" who "spewed their acidulous bile in streams."[96]

Keane's disgust with the New York critics and disdain for modern art would be given a platform when he hired Tom Wolfe to write the introduction to *Walter Keane* (Johnson Meyer Publishing, 1964), his vanity art book project. Wolfe wasn't yet the white-suited avatar of New Journalism. His first book was not yet published, and he was still drawing a stipend from the *New York Herald Tribune*.

95

Wolfe's pseudonymous blowjob (under the pen name "Eric Schneider") may be the loopiest bit of mercenary rhetoric ever placed between the covers of an art book. He mocks the pedantry of art criticism and the infinite pretension of his subject by elevating Keane kids to visual expressions worthy only of the great masters:

> *Indeed, in retrospect, Keane's short Business Period appears almost as a fortuitous ritual of purification. So complete was Keane's isolation, in terms of the world of art, during those crucial years that his own art and his own artistic instincts were able to develop on their own terms. Thus, whereas the average American art student of that period, or for that matter, of our own times, went to Paris already a somewhat slavish devotee and cult worshipper of French Modernism, Keane was able to examine it as a*

possibly useful tool and then discard it when he saw the very specific limitations it would impose upon an artist of his own limitless ambition.

… Keane paints the eyes with the same full-faced perspective of the primitives but with complex, mysterious, almost oracular combinations of thick and thin pigments, and highlights that seem to come, as it were, from an unseen world beyond the immediate image, so that the eye as a thing of depth, of penetration, of admission to the secret self, attaints a power that not even the primitives, in simple acts of faith in the eye symbol, could feel.

96

The end result, of course, is the Keane vision, seen by the viewer as the subjective content that gives Keane's work an emotive fission that explodes, continually, almost in the manner of an infra-red flash, from the very firmness of line and contour that give the work, as form, an unparalleled sense of formal structure. Alternately pouring forth from, and seen within, these eyes are a consummate summation of the anguish, the fear, the despair, and yet the flame-like hope, of a world wracked not only by momentous political cataclysms but assaults on former seemingly immovable investments of simple religious and intellectual faiths, buttressed, at the time, by cultural frameworks that seemed then so unflinchingly embedded, now merely terrifyingly evanescent.

... With "Tomorrow Forever" Keane reaches such an extraordinary level of achievement that the mind boggles at the thought that this still young artist has within him the potential to achieve even greater levels. [97]

Isn't this the angel Bernard's spiel from Walter's autobiography? Yes it is, almost word for word. Apparently Wolfe's glowing introduction was the gift that kept on giving, as Walter randomly borrowed many other purple effusions from Eric Schneider and jarringly inserted them in his memoirs among his stuttering prose. Sometimes he had trouble even copying—a Wolfeian coinage, "cenophobiac moon," becomes in Walter's book a malapropish "xenophobic moon."

Whether the paintings were loved or hated, the early to mid-1960s were the high-water mark for the Big Eye craze. In the years that followed, the Keane brand would continue to generate revenue, but slowly wane in consumer popularity. Perhaps the pinnacle of Keane fame was a widely read profile of Walter that appeared in *Life* magazine on August 27, 1965. When Walter graced its pages, the magazine known for its spectacular and award-winning photojournalism was also starting its slow decline. The publication's motto, "To see *Life*, see the world," had begun to sound quaint now that television was beginning to supplant newspapers and magazines.

If *Life* wasn't the popular magazine it once was, the publication still enjoyed over eight million subscribers, and to appear as a subject of one of its articles meant you had arrived. The six-page spread on Keane (Jackson Pollock had only received four pages a few years earlier) was something of a turning point. If Walter and Margaret had started out on the fringes of the art world, the paintings were now getting serious recognition. The 4,000-word profile was penned by Jane Howard, a veteran *Life* correspondent who would go on to write an acclaimed biography of Margaret Mead. The article, "The Man Who Paints Those

Big Eyes: The Phenomenal Success of Walter Keane," suggests that Jane Howard was not indifferent to Walter's charm.

Keane's love of booze, good food, and loose women was given center stage as Howard described him as "an outstandingly flamboyant and sybaritic figure even in San Francisco where flamboyant and sybaritic people are common." And she hit all the usual notes: his Nebraska upbringing, artistic odyssey to Paris, the starving German war waifs ("My psyche was scarred in Europe"), the early years in North Beach and sudden astounding success. If anything appeared different in the article it was Walter's sense of self-importance. The folksy and often self-deprecating persona that characterized his first interviews was now replaced by a high-living artist unashamed of his success. "It takes dispassionate bravado to speak of oneself in the third person," Howard observed. "Walter has such bravado: it is one of the chief reasons for his success."[98]

When asked about the hundreds of Big Eye imitators who had co-opted his waifs, Keane showed little fear of being upstaged, and offered one of his more memorable quotes, likening his eyes to those of El Greco. If some of his comments seemed bold and outrageous, he also tried to emphasize that there was a serious purpose behind his antics. At one point Walter grew somber and launched into a short reverie about his beloved waifs. "In their eyes," he told Howard, "lurk all of mankind's questions and answers. If mankind would look deep into the soul of the very young, he wouldn't need a road map...I want my paintings to clobber you in the heart and make you yell, 'DO SOMETHING!'"[99]

Howard also talked to Keane's critics. Selden Rodman, a well-known author and art collector, offered one of the more interesting critiques of the Keane waifs. "Real poor children," he told Howard, "do not stare at one with sad, imploring eyes. They grimace, laugh, stick their tongues out, snarl, or turn away from one's presumptuous concern with contempt or boredom. None of them are dressed like these

synthetic waifs in matching pastel colors." John Canaday, Walter's nemesis from the *New York Times*, also made a cameo appearance and derided the "haunting eyes" as "the old principle of a three-dimensional object on a two-dimensional surface."[100]

There were also some well-known fans of Keane art. Joan Crawford, who used two Keane canvases on the set of her 1962 thriller *Whatever Happened to Baby Jane*, offered unqualified praise. "Keane paintings are my friends," she told *Life*. "I wouldn't buy them if they were commercial, I buy them because I love them and want to live with them. I had a fountain designed just to go with one." Crawford's 1971 memoir, *My Way of Life*, featured a cover image of Margaret Keane's portrait of her in addition to compliments inside. The *Life* magazine article noted that Red Skelton, Natalie Wood, Kim Novak, Jerry Lewis, and other celebrities had also purchased Keane paintings.[101]

Howard, who mentioned that Big Eye art was not dissimilar from the increasingly popular Pop Art movement, went on to quote Andy Warhol, who had nothing but kind words to say about the waifs. "I think what Keane has done is just terrific," he told Howard. "It has to be good, if it were bad, so many people wouldn't like it." Warhol even offered Jane Howard an interesting theory as to why the Keane paintings were so popular. "In a lot of ways," he explained, "Americans are like children—I mean we aren't very grown up. But what *I* like most about Keane, myself, is that he's mass-produced, like a factory. I think he'll end up being something like Disney."[102]

If Walter was given center stage by *Life* magazine, Margaret and her Modigliani-like women were briefly mentioned as an aside. For the most part we hear that she is shy and retiring "except when conversation turns to the occult," a "subject in which she is impressively well-versed."[103] Apparently Margaret had a thorough knowledge of astrology, numerology, palm-reading, and various other non-traditional spiritual beliefs. The *Life* article also revealed the first signs of marital discord between the Keanes.

At the time Howard interviewed them, the two had recently separated. If the split was depicted in the article as being largely amicable, there were also signs of tension between the two. "Walter's just too difficult for me to live with," Margaret told the magazine, "but I admire his genius tremendously," she added. Keane offered similar praise to his estranged wife, with some mild criticism. "Margaret is probably the greatest woman painter alive," he remarked, "but if you know what I mean, she rattles. I always used to tell her: Margaret quit rattling."[104] As if to prove his point, he related a story where Margaret refused to board a flight to New York after reading an ominous horoscope.

Apparently Walter was making the most of his new status as an eligible bachelor. "Along the permissive littoral of California," Howard observed, "there is probably no man more outspokenly in favor of the female sex than Walter Keane." Of course his "observations on the subject are not always delivered in well-modulated tones or in printable language," but Keane wasn't the kind of man who worried about social niceties. Now that he'd made it, he wasn't going to worry about public opinion either. "If you don't collect your due and milk them for what they're worth," he explained, "you're a fool. I know money gets paid for what I do—after all, fortunes have been made reproducing it—and I just want my share."[105]

And who would deny him that? Howard ended the article to the sound of glasses clinking together as The Man Who Paints the Big Eyes ordered up another round of Chivas on the rocks at a favorite North Beach bar. "All an artist really needs," Keane decided, "is a little space to paint and sleep. Women? He can have so many women he'll need Entrance and Exit signs."[106]

He didn't know it at that time, but Walter's boozing and womanizing would come with a high price. Margaret was now out of the picture, but he made a major miscalculation. He needed his former wife's cooperation if he wanted to keep the Big Eye machine humming

along. Yet once she was on her own and had some time to think, his hold on her would become increasingly tenuous. In due time, she would step forward and reveal the lies behind her husband's public image. He never saw it coming.

The Split:
Going Their Separate Ways

When Margaret and Walter finally gave up on the marriage, it was an uneventful affair. Just a few months before the *Life* magazine article ran, Margaret's request for a legal separation was heard in San Mateo County Court. She testified in court that her husband was for the most part "jealous, critical and unpleasant."[107] Keane didn't contest her claims and the decree was granted. Walter was apparently so unconcerned by the proceedings that he skipped his court date and was off in the South Seas enjoying one of his Gauguin-with-a-Scotch-tumbler artist retreats. It's likely he felt he had little to worry about—Margaret waived all claims for financial support and the couple agreed to continue their existing business arrangement.

So the marriage was over. If Walter didn't exactly come off as the model husband in the courtroom, he wasn't worried about it. Little would change, he believed, once they'd parted. His ex-wife would continue producing his trademark waif paintings just like before. Except now there weren't any matrimonial entanglements. He was single again, a swinging bachelor with a fat bank account.

Margaret wasn't quite so optimistic about the future. For ten long years, she had lived in Walter's shadow and that didn't do a lot to bolster her confidence. She later admitted that one of the primary

reasons she'd stayed in the marriage for so long was because she wasn't sure she could make it on her own. "I didn't know what to do," the artist explained to a television interviewer in 2012, "I didn't think I could support myself and my daughter, and he'd brainwashed me it was my fault he couldn't paint."[108]

Yet now she'd taken that momentous first step. Margaret would later reveal that the legal separation was part of a larger plan to permanently break free from Walter's grasp. "I got a separation to begin with and went to Honolulu to get as far away as I could," she recalled in a later interview. "When I got more courage, I came back and filed for the divorce. I was just happy to get out alive."[109]

Now that she'd made that first major break, Margaret began rebuilding her life in Hawaii. Yet she wasn't sure what to do next, being a bit shell-shocked. She would later say that she'd come to dread Walter's controlling behavior and explosive temper. "Now, looking back on it," she reflected in the interview, "[I was] really abused… not abused physically but emotionally—totally abused. I wasn't even allowed out of the house."[110]

Margaret was also a 38-year-old single mother with two failed marriages behind her. Though she didn't know it at the time, her best years were ahead of her. She enrolled Jane in summer school, and took time off to get much-needed rest and to collect her thoughts. She was often depressed and found it hard to paint. "After I filed for divorce," she recalled, "I painted a few paintings and mailed them to Walter. I was so afraid of him I thought if I kept mailing him then he wouldn't have me killed. That's how mixed up I was." [111]

Meanwhile, back in California, the waifs continued to sell but were losing their hold on the public. Over the next few years, the Big Eye craze began a slow but steady decline. Despite his flair for publicity and media connections, press coverage of Walter and his lost children began to dry up. The waifs also began to face increasingly stiff competition from a variety of imitators. Painters who used names like

Gig, Eve, Eden, Dallas Simpson, and Ozz Franca pushed the Big Eye market to the point of saturation. Big Eye black velvet paintings, Big Eye needlepoint, Big Eye paint-by-number, Big Eye porcelain plates, Big Eye string art, Big Eye porcelain figurines—some using the Keane name, but most frequently without.

Walter Keane started to have trouble running the business. There were galleries to manage, licensing deals to negotiate, shows to arrange, press materials to circulate, and dozens of other small but significant details. If Keane seemed to enjoy the frenetic pace, he was also putting away a lot of scotch. And, like many high-functioning alcoholics, Keane's continued success gave him little incentive to cut back—he'd gotten pretty far with Chivas Regal by his side, why quit now? Unfortunately, at some point the booze would gain the upper hand. The ugly drama would play itself out during Keane's third and final marriage. And it all began with a memorable encounter on a United flight from San Francisco to New York:

105

My eyes drifted across the aisle into row one facing me. There she was. As though in a dream, I became mesmerized by her. She pulled her skirt up showing her ivory-colored flesh beneath the lifted skirt and crossed her shapely legs, the right calf now in full view. I called out, 'Colette.' The plane was leveling off but I was still climbing. The legs unwound. A gracious lady stood up as though disguised in a United Airline stewardess uniform. She removed her jacket with breasts in full-bloom pressing her white shirt buttons as if they were going to pop off … I shouted 'Dana it's you!' She turned. As the light changed on her face, I said, 'No, it's Colette.' My God, they have melded into one person and come back to me. She

*was moving slowly as though reeled in toward
me on a line. She leaned over and in a quiet se-
ductive voice announced, 'I'm Joan Marie, your
stewardess.' She handed me a Chivas Regal on
the rocks.[112]*

The comely stewardess with the piercing blue eyes was Joan Marie
Mervin, Walter's soon-to-be third wife. In his memoirs, Keane placed
his love-struck plane ride sometime before the unveiling of *Tomorrow
Forever* in 1964. Yet the book's often confusing chronology leaves
room for some skepticism. It doesn't seem likely that Joan, a practic-
ing Catholic, would be willing to get deeply involved with the still-
married Keane. Walter was also publicity-conscious, and his high-pro-
file courtship of a woman half his age while still married to Margaret
wouldn't have played well in some of the more conservative parts of
the country.

Then again, he may have been seeing Joan on the side all along
while he kept up appearances with Margaret. Interestingly enough,
Walter alleged that Tom Wolfe made a cameo appearance on the cou-
ple's first date. "Oh by the way," he supposedly told her after the two
agreed to meet for lunch at the Plaza Hotel in New York, "I will be
having lunch with a friend of mine. You will enjoy meeting him. His
name is Tom Wolfe, a creative ambitious young writer, a genius with
words. One day he may write the great American novel."[113]

Hours later, when the two repaired to Walter's sometime apart-
ment at the Wyndham Hotel, romance was in the air:

*As her blue eyes gazed deeply into mine, she
spoke softly, "I must be going soon."*

*Like a traffic signal changing from yellow
to green, we wrapped our arms around each*

other and kissed. Again with direct eye contact, I spoke. "Joan Marie your eyes are penetrating me like an assault with a deadly weapon."

"Walter, I don't want to wound you."

I was speaking, feeling, touching as though I were with two women, Colette and Joan Marie. Words flowed from my heart. "As of now, I declare you My Woman."[114]

There's not a lot of public information about Walter's final wife, so we'll have to rely on his memoirs and hope he got a few things right. According to Keane, Joan, a native of British Columbia, was an art student in her third year of study in Canada when she left college to work in the U.S. as a stewardess. Her father was a native of Argentina and her mother was a mixture of Russian and French. Apparently her mixed background and stunning profile gave her a "radiance" Walter likened to a "rare jewel, clear as a crystal."[115]

As in his marriage with Margaret, Walter apparently envisioned some kind of partnership with the artistically inclined Joan Marie. Sometime after the two met, they spent a memorable evening at Joan's apartment. The next morning, in a confessional moment, a blissful Keane revealed to Joan Marie his visionary plan to build a global art empire.

A vision, a dream has stayed with me along my journey to reach out into the world and gather together the fine painters I've met everywhere and bring their work together into a group of fine galleries. California would be a good place to start. We could open a group of galleries

*along the coast of California, then the nation
and eventually throughout the world...I am
aware the artists could not find me or send their
paintings to the galleries. I must go to them.
Pay them in advance for their work. Financing
them, if need be, to buy canvases and paint for
them and pay their rent. This would encourage
them to continue as artists and not drift away to
meaningless jobs. Eventually we will establish
a worldwide group of galleries for the benefit of
the world's artists.*[116]

When the divorce with Margaret was finalized, Walter married Joan in 1969. Bob Miller, a friend, remembers meeting the couple in the 1970s. "They seemed to be happy," he recalls. Apparently Walter's new wife wasn't like his ex at all. "She was outgoing," Miller says, "definitely a contrast from Margaret who was very pleasant but shy and quiet."

Like Walter, Margaret would also remarry before the decade was over. She'd barely been in Honolulu a month when she fell for another charming Irishman. Dan McGuire was a veteran journalist who had worked in and around newsrooms for most of his life. He'd covered sports for various Bay Area newspapers and during the war had spent time in the Pacific theater as a foreign correspondent for UPI. After the war, McGuire returned to San Francisco, where he took up a new post as publicity director for the San Francisco 49ers. In 1960 he wrote a chronology of the team's early years that's still considered a classic by longtime fans.

The two were married by 1966. The year before, he'd left the 49ers job to take a post at the *Honolulu Advertiser*. For the next eighteen years, he went on to pen a column. During his best years, McGuire was considered one of the nation's top sports writers. And he was

the kind of man who left a positive impression on everyone who encountered him. When McGuire passed away in 1983, Bill Kwon, an editor at a rival paper, remarked, "Nobody ever disliked Dan. He never hurt the English language or anyone in his 43 years in journalism. He gave our profession a good name."[117]

McGuire also provided some much-needed encouragement and support to his new wife. As Margaret would later remark, "He helped me a lot to become less timid and afraid."[118] Her self-confidence restored, she began to show a new assertiveness. One of the first issues she raised concerned money. Prior to their legal separation the couple had drawn up a business agreement. Walter agreed to promote and sell her paintings and she would get a percentage of the profits. The payments were to be sent monthly. In December 1966, Margaret filed a lawsuit in federal court demanding to examine Walter's business records as she had yet to receive so much as a dime after their subsequent divorce. Keane claimed in his memoirs that was the suit was later dropped when his accountant provided cancelled checks showing she'd been paid.

The lawsuit was just the beginning of Walter's troubles. Under the headline "Keane Loses Cash, Oils to Bandits," a story appeared on May 27, 1967 in the *Oakland Tribune* that described a frightening morning robbery at Walter's home on Woodside Drive. According to Keane, two men who wore gray gloves and "talked with Boston accents" stealthily entered the residence in the early morning hours and pounced on the unsuspecting gallery owner while he was getting dressed after a shower.[119] The two suspects allegedly tied Walter up and threatened his life unless he revealed where he kept his cash. The robbers left with $30,000 in cash and an estimated $10,000 worth of art. Fortunately, Keane was able to knock over a telephone and dial an operator for help. The two suspects were never arrested.

It was certainly a strange encounter. Home invasion robberies weren't exactly common in the plush Woodside neighborhood where

109

Walter lived. Yet he may have drawn some unwelcome attention. He had a reputation for free spending and having wild parties at his home. Keane also liked to frequent the bars in North Beach, where his opulent lifestyle may have been noticed. Of course, Keane had few doubts about who was behind the heist.

"Only Margaret and the Swedish installer of the safe knew where I kept my money," he later claimed in his autobiography. He also alleged that his ex-wife told an FBI agent who questioned her about the robbery that "she might have told someone about my safe while she was drinking."[120] His belief that Margaret was somehow behind the break-in may have signaled the beginnings of what was to become a full-blown paranoid obsession with his ex-wife. And it was about to get worse.

Happy and secure in her new marriage, Margaret came to an important decision. She would no longer play a role in Walter's ongoing deception about her paintings. "I got to the point that I decided I wasn't gonna [sic] lie about it ever again. If anybody asked me I would tell the truth."[121]

She was true to her word. On October 14, 1970, while visiting San Francisco to finalize a lithographic series for a Bay Area gallery, Margaret met with a UPI reporter. During the interview, she made the stunning revelation that her husband had never painted the waifs. If she was gracious about her ex-husband's promotional genius, she had little good to say about his painting abilities. "He wanted to learn to paint and I tried to teach him to paint when he was home—which wasn't often," she recalled. "He couldn't even learn to paint."[122]

She also made a bold challenge. "Give us both paint and brush and canvas and turn us loose in Union Square at high noon and we'll see who can paint eyes," she promised. "I'd like that."[123] The "paint-off" ended up being anti climactic, as Walter never showed up. If he thought ducking the event was a good idea, it backfired. The UPI article was picked up by several newspapers and *Life* did a follow-up

story calling Margaret the "undisputed leader of the Big Eye school of art."[124]

In response to the rash of negative publicity, Walter decided his best approach would be a smug, condescending tone. "I'd rather daub than smear," he glibly told *Life*.[125] "The really surprising thing is that it's Margaret getting up and saying this," he remarked to UPI. "It isn't at all like her. I remember her as a sweet person, very shy and retiring, and a sensitive artist, I simply refuse to believe that [the paint-off] was her own idea." He also reminded the reporter that Margaret was "not yet a teenager" when he was studying art at the Beaux Arts.[126] Years later, Walter would say he simply wasn't available for the paint-off. "I never heard of the article," he recalled. "I was overseas and nobody knew where I was. I didn't read anything."[127] When his crisis management efforts failed, Keane did the only sensible thing. He packed up and left the country with his new wife. He probably hoped things would blow over.

Meanwhile, for the first time in years, Margaret began to enjoy a measure of happiness. She'd put her ex-husband out of her mind and, much to her relief, had finally told the truth about her waif paintings. She was painting again, her daughter Jane was thriving, and her marriage was a harmonious one. And she was living in a tropical paradise—a place she called her "favorite spot on earth." Yet life wasn't always perfect. Sometimes she couldn't shake a pervasive sense of unease and smoked at least a pack of cigarettes a day. There were moments when she turned to alcohol to insulate her troubled mind from these episodes of nervous tension. She also continued to ponder the deep metaphysical questions she'd first asked in her early years.

Like many Americans at the time, Margaret had cast aside her childhood religious upbringing and spent years experimenting with a variety of religious and spiritual teachings. As she later recalled, her search led her to "strange and dangerous places," and at various times she dabbled in the occult, graphology, palm-reading, and astrology.

111

She also read lengthy tomes of Eastern philosophy and briefly became a practitioner of Transcendental Meditation. Margaret also explored some of the more conventional religious orders, studying Lutheranism, Catholicism (her husband Dan was a Catholic), Mormonism, and Christian Science. "I still found no satisfactory answers," she later wrote, "always there were contradictions—and always there was something missing."[128] And then one day, two Jehovah's Witnesses knocked at her front door.

The Jehovah's Witnesses (also known as the Watchtower Society) has existed on the fringes of American religious life since the late nineteenth century. The movement can be traced back to 1879 when a Pennsylvania minister named Charles Taze Russell started a publication called *Zion's Watch Tower and Herald of Christ's Presence*. Russell argued that mainstream Protestantism had become corrupted and urged his readers to return to a purer, ancient form of the faith, akin to that practiced by Christians in the first century. He also argued that many core Christian concepts like the existence of Hell and the idea of a Holy Trinity had no biblical basis and were therefore false doctrines.

If his ideas were controversial, they also generated enthusiasm among his subscribers, who began to form congregations throughout the country. Over the next few decades, the movement grew. In 1931, at a Watchtower Society convention, a resolution was passed adopting the name Jehovah's Witnesses, as part of an overall recruiting effort. Today, there are over seven million Witnesses in over two hundred countries.

Since 1909, the Watchtower Society has been headquartered in Brooklyn, New York, where the movement is led by an eight-member elite who decide questions of doctrine and oversee proselytizing efforts. Witnesses are perhaps best known for their door-to-door evangelism, which is a key tenet in their belief system. They cite Matthew 10:7, 11-13, where Jesus directed his disciples to enter the homes of the people to spread his message. The Watchtower Society is also a

major publishing enterprise, and every year issues millions of pages of printed materials, such as the movement's two periodicals *Awake!* and *The Watchtower.*

Witnesses share many beliefs and practices with fellow Christians. Weekly services are held, baptism and communion are part of their rituals, and like many fundamentalist groups, they strongly believe that we are in the "end times" and Armageddon is near—at one point they said the world would end in 1975. However, in many ways Jehovah's Witnesses are markedly different from other Christians. For one, they don't believe in the cross, which they see as a pagan symbol. Witnesses also refuse to celebrate Christmas, Easter, and any other allegedly pagan and/or nationalist holidays. Blood transfusions are also considered sinful, as members believe the Bible specifically forbids this practice. Male members are prohibited from serving in the military due to the movement's long-held opposition to war. Needless to say, this created frictions between the Witnesses and civil authorities throughout the twentieth century.

From the very outset, the two Jehovah's Witnesses (a pair of Asian women) who came to Margaret's door impressed her with their vast knowledge of the Bible. At their encouragement, she began studying the Bible with her daughter Jane and reading Watchtower literature. She also began to question some of her long-held assumptions. "In this study of the Bible," she later wrote, "my first and biggest hurdle was the Trinity. Since I believed that Jesus was God, part of a Trinity, having that belief suddenly challenged was like having a rug pulled out from under my feet." She found herself "besieged with doubts, even about there being a God at all."[129]

What made her even more fearful was the fact that her daughter Jane had not only accepted the Jehovah's Witnesses, she had decided to become a missionary. "Visions of my only child in a far-off country frightened me, and I decided that I must protect her from doing something so drastic."[130] So she scrutinized ten different translations

113

of the Bible, and various dictionaries and reference books, in the hopes of disproving the Jehovah's Witness doctrines. To her amazement and joy, she ended up being the one convinced. In August, 1972, Margaret and Jane were immersed in the Pacific Ocean and baptized as Jehovah's Witnesses—a decision Margaret believed dramatically changed her life for the better.

She has said that her new faith helped her quit smoking, but that was just the beginning. "Other changes were deep psychological transformations in my personality," she wrote. "From a very shy, insecure, introverted and self-absorbed person who sought and needed long hours of solitude in which to paint and relax my tensions, I became a much more gregarious, outgoing person."[131] Fired with her newfound faith, she even began knocking on doors along with her new co-religionists. Her art was transformed by her spiritual awakening. Paintings she used to spend hours on were finished in half the time. And even her waifs began to show signs of her awakening hope and happiness—they now began to smile. Perhaps the Jehovah's Witnesses, with their tracts promising an earthly K-Mart utopia, were a wholly appropriate aesthetic environment for Margaret's latter-day grinning Big Eye waifs.

In 1974, she went public with her religious conversion, telling the *Hayward Daily Review* that she'd found "abiding happiness" as a Jehovah's Witness. "I realized that to pin happiness on worldly success is too precarious," she told the newspaper. "The lasting accomplishments are the spiritual ones and they are the only ones we can hold onto."[132]

For the next twenty-five years, even after Dan's passing in 1983, Margaret would continue to paint and successfully market her work in the islands at the Margaret Keane gallery in Waikiki, although she didn't quite achieve the fame and renown she enjoyed during the glory years with Walter. She also faced obstacles in her new island setting. "She was very successful in Hawaii, but it was very isolated," Robert Brown, her longtime business manager and salesman, told the

New York Times in a 1992 article. "People thought they were done by her former husband or thought she was dead."[133]

While Margaret found love, spiritual bliss, and artistic success in Hawaii, Walter's decade-long European odyssey was an altogether different story. After putting up $250,000 for his international gallery venture and writing checks to dozens of artists, it never got past the planning stage. His dream floated away in a sea of booze.

Of course there were some good times as well. According to his memoirs, there were meetings with the Pope, the governor of California, Liz and Dick, and Madame Chiang Kai-Shek. In 1970, Walter and Joan celebrated the birth of their daughter Chantal and flew to Martinique, where Walter charmed the pants off the native girls and had to fight off the advances of a gorgeous young model ("She looked at me with confidence and daring. She was challenging me to take her...").

From there, they were off to Paris, where Walter set up a beautiful young girl in law school. And then tragedy struck. "The twenty-two oil paintings I had done in Martinique plus the eleven oils from my California studio had been lost at sea," Keane recalled bitterly in his memoirs.[134] (It should be pointed out that all of Walter Keane's art production since his divorce from Margaret was either "lost at sea" or salted away with "private collectors.")

In 1973 a son, Sascha Michael, was born, and although he claimed a happy marriage and cherished his new son and daughter, Walter drowned his physical and mental pain in pills and ever-increasing amounts of scotch. The years began to fly by. "I was drinking, drinking, drinking," he recalled to a reporter from the *Orange County Register* in the mid-1980s. "Two quarts of Chivas Regal a day. Frankly I just don't remember much from those years."[135]

It's difficult to figure out the exact chronology of when Keane left for Europe and returned to the United States. Margaret has claimed that Keane left for twelve years after she questioned his painting

115

abilities in 1970, but Walter and Joan also spent time in La Jolla, where they would later settle. By the early 1980s, the Keanes had relocated to La Jolla and the new environment did little to stem Walter's drinking. Finally his long-suffering wife Joan couldn't take it anymore:

> *Often when Joan and I talked, her eyes shone through the tears. My whiskey had numbed me; I believed that nothing could ever come between us. Holding her in my arms one evening, I said "What I need is an understanding heart."*

> *Joan replied, "You have one; her name is Chivas Regal. And I might add that she is a very expensive lady." This comment is as close as she ever came to criticizing me. In our relationship, Joan never used strong or offensive language.*

> *Financial problems had begun to surface. My mismanaged wealth, carelessly squandered, was almost totally gone. The depletion of my money matched the disintegration of my body and my emotional well-being.*

> *I sometimes felt on my way to death itself...*[136]

Joan left him and moved back to Canada with the children. The love of his life gone, his business in tatters, Keane's life was unraveling:

> *I wondered how or if I could survive without my family. It would be a difficult adjustment.*

116

At that point the emotional pain was far greater than any physical discomfort I had ever know [sic]. 'It was like a darkness had fallen on my life.' It made me wonder if artists and idiots are one.

The reluctance of the sun to shine, the cold nip in the ocean breeze, the sound of the waves and the patter of the falling leaves drifted into winter. Christmas found me alone, totally alone.[137]

And it was going to get worse. The long-forgotten Big Eye controversy would flare up once again and deal a crippling blow to Keane's reputation as an artist.

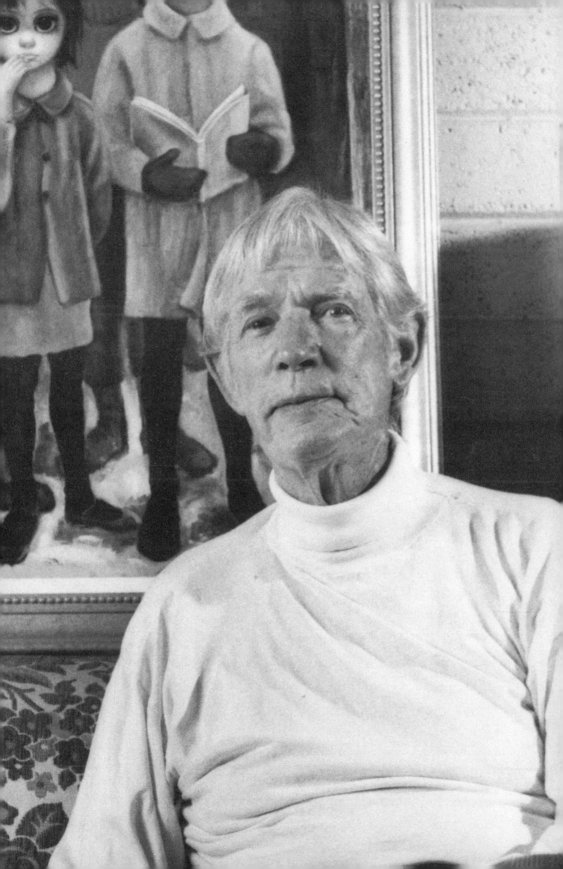

Down and Out in La Jolla: Walter's Last Stand

When someone has a serious drinking problem, it often has to get worse—a lot worse—before it gets better. Rehab counselors call it "hitting bottom," that moment of personal crisis when an alcoholic realizes his or her drinking is out of control and has to stop. In most instances, all it takes is the loss of a job, a drunk-driving arrest, or a frightening alcohol-related hospitalization. Yet those who have tasted fame and success often find it hardest to admit they have a problem. When you've been a wealthy and well-respected public figure for most of your life, it's hard to think of yourself as a hopeless drunk. So celebrity artist Walter Keane, now a senior citizen living in La Jolla, had yet to reach bottom. He continued to numb himself with scotch, even after his drinking had destroyed his third marriage and eroded much of his fortune.

Walter's daily existence mainly revolved around his favorite haunt, the Whaling Bar at the La Valencia Hotel in La Jolla. The darkly ambient cocktail lounge, which had a large mural of a whale hunt hanging above the bar, had the feel of a nineteenth-century maritime pub. The walls were adorned with whalebone carvings, harpoons, and nautical-themed paintings. The place definitely had character and Keane may also have identified with the pub's reputation as a refuge

119

for writers and artists. Author Mary Duncan, who moved to La Jolla in the early '80s, didn't remember Keane fondly when she wrote an epitaph for the bar when it closed in 2013. "I remember sitting downwind of Art Buchwald's smelly cigar and being annoyed by artist Walter Keane's cigarettes," she remembered. "Keane, who was famous or infamous for his big-eyed waif paintings, lived in a 'peasant's shack' overlooking the beach."[138]

Walter's proximity to the bar made it easy to become a regular and once Joan and the children left for good, his life became carefully regimented. On a typical day, Keane would eat a small breakfast in the morning, and, ever the devoted father, write to his son and daughter and then drop the letter off at the post office. Then he would walk over to the La Valencia hotel and settle into his favorite corner seat at the Whaling Bar. Usually, he'd drink until the late afternoon, and then head home for a quick nap, something to eat, a cup of tea and a shower. Once refreshed, he'd amble back over to his corner seat, drink until closing time and then stagger home.

It wasn't much of an existence for a man who used to be forever on the go, traveling to New York, London, Paris, Madrid or some gorgeous island vacation spot. And in past years there were always people in Walter's life: Susan, Joan and the children, art dealers, reporters, CEOs, celebrities, politicians, and his ever-widening circle of friends and acquaintances. And when it came to his friends, Walter could be generous to a fault. "As some people get each other packets of gum," Jane Howard observed in her *Life* profile, Keane "impulsively buys friends potted azaleas, dresses, hand-worked leather sandals or sessions at glamorous beauty salons. When he takes a long distance call, his first words are often, 'Baby, you should have called *collect*.' "[139]

Now, the phone wasn't ringing like it used to and he felt alone and abandoned. That's not to say he wasn't as personable as always when a friend dropped by. He was often able to put aside his problems or his

disputes with Margaret and focus on enjoying the moment. "In my subsequent meetings with Walter," Bob Miller remembers, "we never really discussed who painted what."

If he could just pick up a brush and channel his heartbreak into his painting—but there was always the shoulder...the painful shoulder injury he said left him unable to paint. So Walter continued to drink and the days blurred into weeks and then into months and then...the unexpected happened: Keane experienced his moment of clarity.

It was late in 1981 and it was just like any other evening. Keane polished off a double scotch and left the Whaling Bar at closing time. He now began the short lonely walk to the small cottage he called home. On this particular night, the rain was pouring down, visibility was poor and Walter quickly got drenched. At one point, he paused as if he didn't have the energy to complete his short journey. And then it happened. As he recalled in his autobiography:

121

I hit the wall...

I was sinking down fast, sinking down, down, down. Head bashed in, blood dripping on my body. Soon, I lay in my own splattered blood, having fallen in the turning circle. I was dazed, lost, confused, with my bloated and throbbing nose, a complete mess in the solitary darkness. My mind was mumbling, 'I'll soon be sending greeting cards from Hell.' I had drunk away my family, my health, my wealth, and now I was drinking away what little remained of my life. Then a sound like angels' wings fluttered above me...from out of nowhere two strong arms wrapped around my tired, limp and almost life-less body, lifting me to my feet. As I gained my

balance, a severe test of bodily strength at the time, the shock of the massive wall stared me in the face. A familiar voice, becoming more and more clear, embraced me with loving words: "My little Walter, you can now walk through the wall and continue your drinking until death. Or you can steady yourself... turn around and walk to freedom."[140]

Much to his credit, Walter made the walk to freedom. He would later say the unfortunate and painful collision with the concrete wall left him a changed man. "That was the night I knew I had to do something about the drinking," he later told a reporter.[141] This was a life-changing decision.

At the time he regained his sobriety, he was sixty-six years old and booze had been his constant companion for nearly fifty years. He tried quitting cold turkey at first, but then a longtime friend put him in touch with Alcoholics Anonymous (AA) and he began to attend meetings. He also attended lectures by Dr. Vernon Johnson, Betty Ford, and other outspoken former alcoholics at Scripps Hospital.

He embraced his newfound sobriety and swore off alcohol for good. His children were overjoyed. It wasn't always easy. "It's tempting," he confessed. "You think, 'Gee, if I could just learn to like wine instead of the hard stuff'... But no, you're kidding yourself when you think that. For me, I've got to handle the world in sobriety."[142]

And reality can often be a disappointment; the world he experienced with newly sober eyes was an altogether different place. He called this new chapter in his life, "my new awakening, away from the drinking world of exciting sexy beautiful women, parties, and art buyers."[143] The country where he'd grown up, worked hard and lived the American Dream had changed a great deal during his sojourn overseas. The final pages of his memoirs reflect an old man's

sad nostalgia for simpler (and better) times. "A mechanical way of life has supplanted the small town intimacy of my days with Grandmother," he complained. He now lived in a world of "word processors, credit cards, frozen food and disposable diapers." American homes were now inhabited by "zombies watching television" and as far as he was concerned, it looked like the country was "on the skids."[144]

Yet there was still a small reserve of Keane's old optimism. He may have gone through the twelve steps with a certain amount of humility, but the old ego was still intact. Walter missed being in the public eye. If he couldn't paint, at some point he realized he had an amazing story to tell. Who wouldn't want to hear about the many celebrities he'd met, the beautiful women he'd loved, and the waifs he'd painted? And there was also Keane the victim.

Keane began to view himself as a misunderstood figure, a national treasure unfairly marginalized by a fickle and uninformed news media and a bitter ex-wife. The autobiography wouldn't just tell his amazing story. He would also have a platform to expose the sinister misdeeds of his supposed enemies and detractors. And if Keane's book succeeded, he might just regain some of his former stature and possibly gain a whole new generation of fans. So the would-be author signed up for writing classes at UC San Diego and began work on his life's last great project—what he would later call a "wild, exciting, heartbreaking, sexy autobiography."

123

And this is where his plans began to unravel. If Walter was sober, that didn't necessarily mean he was mentally sharp. Decades of boozing and old age had taken their toll. His memory wasn't always clear. Names, dates, and other critical information often seemed to be just beyond his grasp. If he still had some of his former charm, the less endearing sides of his personality had also become more pronounced. At times he could be angry, paranoid, and unhinged, particularly when it came to Margaret. She was no longer just a disgruntled ex-wife; he accused his former partner of being in league with art fraudsters, the

Jehovah's Witnesses, and other parasites who had cashed in on his name and reputation.

And in his mind, the controversy over who painted the waifs was far from over. Whatever people may have believed in 1970 when Margaret told the world about his deceit and he failed to show up for the paint-off in San Francisco, now he was going to set the record straight. "The BIG LIE was invented by Margaret for herself [sic] to believe in… and she is still telling her Big Lie to the press," he thundered in his memoirs. "The *birth* of the LARGE SAD-EYE-PAINTINGS [sic] was in Berlin after World War II."[145] As proof of this contention he would point to a Property Settlement Agreement that Margaret signed at the time of their divorce. Paragraph C of the agreement clearly stated:

124

> *The parties hereby agree that the fair market value of all the statutory and common law copyrights to Margaret's paintings is equal to the fair market value of all the statutory and common law copyrights to Walter's paintings, and that each hereby exchanges their respective community property interests in all copyrights to the paintings of the other, and each further waives and relinquishes to the other any and all right, title or interest he or she may have in the copyrights to the paintings of the other.*[146]

Keane's first reaction when Margaret raised the issue that she was the one who painted the waifs was to leave the country for years. Now he planned to address the controversy head-on. Perhaps Walter believed that a bitter public squabble would get his name back in the news just like the hungry i incident—or he may have honestly believed that he'd actually painted all those waifs. Whatever his

motivation, he was ready to press his case in court. The estranged couple's eight-year court battle began on April 16, 1982, when Walter filed a $1.5 million copyright infringement suit in Santa Clara County over a July 11, 1981 article in the *Peninsula Times Tribune*, in which Margaret claimed authorship of the waifs. The suit was dismissed with prejudice in February 1984. Keane later blamed the dismissal on his attorney, who he claimed forgot to file proper paperwork.

Meanwhile, he tried his hand at getting some publicity for his manuscript. He no longer had a string of sympathetic reporters he could call on and the well-oiled Keane publicity machine had been inoperable for years. Yet he still knew how to pitch a story and his efforts to generate publicity weren't altogether unsuccessful. Walter landed a couple of television interviews and appeared in a handful of newspaper articles. The aforementioned *Orange County Register* profile ran on May 1, 1984, and if it was positive, it wasn't altogether flattering either. Keane was largely depicted as a name from out of the past, a long-forgotten celebrity.

"The stories begin to blur into each other as he talks," observed staff writer Franklin O'Donnell. "Was that Wife No. 2 or Wife No. 3? Yes, wife No. 3, the final one who left him four years ago, the mother of his 13-year-old daughter and 10-year-old son."[147] The profile recounted his life in the arts (without mention of his dispute with Margaret) and Walter declared that love was his primary motivation. "I suppose, through it all, I've been looking for love," he told the reporter. "And in that sense the hunger of the children I painted was my own hunger."[148]

Keane told O'Donnell he hadn't earned a "single nickel" since he quit drinking but was hard at work on his memoirs, "scribbling off pages a day, working at unsorting a lifetime of patchy memories, a rollercoaster trip through fame and pain." If Keane seemed down on his luck, he still showed signs of his old self. "I feel my paintings will stand the test of time," he confidently told O'Donnell.[149]

And then, once the article appeared, Keane went ballistic. This would become a familiar pattern. Within days of the article's appearance, he wrote a scathing letter to *OC Register* editor Pat O'Riley, calling the article "25 percent accurate" and accusing O'Donnell of making him appear senile. He then flooded O'Riley's inbox with postcards of his paintings, excerpts from his autobiography, and testimonials from supporters. Yet the dispute would quickly be forgotten because he soon had bigger troubles.

In July that same year, Keane was also interviewed by *USA Today*, and this time his publicity efforts backfired in the worst possible way. In the course of the interview, Keane offhandedly leveled an accusation at Margaret that would have serious legal implications. Keane had convinced himself that Margaret was going around telling people he was dead, and he brought this up in the interview. "Thinking he was dead," the article stated, "the second of his three ex-wives (also a painter) claimed to have done some of the Keane paintings. The claim, vehemently denied by a very much alive Keane is in litigation."[150]

The accusation that his ex-wife was telling people he was dead and was falsely claiming to have painted some of his works was a serious charge that demanded a response. Now it was Margaret's turn in the courtroom. The recently widowed artist filed suit in Hawaii federal district court against Gannett Co. Inc. (the publisher of *USA Today*) for libel, and against her ex-husband for defamation and malicious prosecution due to the lack of merit in Walter's earlier case against her. Walter countersued Margaret for copyright infringement once again.

When the trial began on May 6, 1986, it must have been awkward for both parties. This was the first time the estranged couple had seen one another in over twenty years. Yet even before the trial began, Walter's defense began to run aground.

Over a month before the trial was set to begin, Walter's attorney, Seymour Ellison, dropped out of the case when his personal life careened out of control. Once retired, Ellison would later characterize

Keane as "not the best-liked man. He was very contentious." He also added, "I never received a cent from Walter Keane."[151] Keane attempted to get the trial postponed until October, but Judge Samuel King refused to delay the proceedings. As a concession, the judge decided to bifurcate the trial so the libel claims would be addressed first and Keane would have the benefit of Gannett's attorneys to assist in his defense.

The trial began with a lengthy and well-organized presentation by Margaret and her attorneys. Dozens of Big Eye drawings (one dating back to when Margaret was eleven years old), sketches, and paintings were introduced into evidence. The artwork all predated Margaret meeting Walter. Under direct questioning, Margaret explained that she'd always painted oversized eyes but really developed her signature Big Eye style when she began painting her young daughter Jane. She told the jury that it was her deep unhappiness being married to Walter that provided the inspiration for the sad, weeping waifs.

Margaret still had a big hurdle to clear. She had to explain to the jury why she had remained silent so long while her ex-husband took credit for her paintings. Margaret admitted on the stand that she'd willingly played along with her husband's public deception, but for a very compelling reason. She testified that on repeated occasions Walter had threatened her life and the life of her daughter Jane if she ever broke her silence about the waif paintings. Her daughter Jane Ulbrich took the stand and substantiated her mother's claims. Jane also recounted being struck and threatened by Walter as a child. A deposition by a former secretary of the Keanes was entered into evidence during closing arguments that further tarnished Keane's image in the eyes of the jury. Apparently, at one point Margaret had confided to the secretary that Walter had threatened to burn the house down and kill her if she ever tried to leave him.[152]

The presentation was capped off by Margaret's now famous fifty-three-minute painting of a Big Eye kid in the courtroom, which

was entered into evidence as Exhibit 224. "It took one hour," she later recalled. "I did the eyes, the nose and the mouth; then during the lunch break I did the hair and the background."[153] When asked by Margaret's attorneys to provide a similar painting, Walter begged off and complained of his sore shoulder. He also remarked bitterly that "Margaret can copy anything, even a Rembrandt."[154]

It was an altogether persuasive case and things quickly went from bad to worse for Walter's defense. Thirteen days into the trial, attorneys representing Gannett submitted a motion for a directed verdict. A "directed verdict" is a judicial order that reveals that any reasonable jury could find no verdict to the contrary, and no longer is there a need for jury to decide the case. As Margaret was deemed a public figure, there was a higher standard for the libel case, and Judge King felt that Margaret's attorneys had not provided any evidence of actual malice by *USA Today*. King dismissed Margaret's suit against Gannett. This left Walter sitting by himself at the defense table. In what would prove to be a costly mistake, he opted to represent himself for the remainder of the trial.

Judge King would repeatedly lecture Walter on proper courtroom conduct and called him "vitriolic." Walter's outlandish accusations against Margaret—which included accusing her of various sexual indiscretions—stretched the judge's patience to the breaking point. "I guess if you haven't any money," King observed at one point, "you can libel anyone and get away with it."[155]

As a witness for the defense, Keane called a longtime friend, John May, to testify under oath that he'd seen Walter's Big Eye kids long before Margaret became acquainted with him. Under cross-examination, May admitted that he had never actually seen Walter paint. Keane's countersuit was thrown out by the judge, as Walter had submitted no evidence that Margaret had reproduced any of his copyrighted paintings. The jury came out in Margaret's favor and she was awarded $4 million in damages. The courtroom victory dealt Walter's

already faltering public image a massive blow. "I really feel that justice has triumphed," Margaret told *People* magazine after the verdict.[156]

Fearing that the huge judgment would remove all possible avenues for appeal, Walter filed for bankruptcy on May 29, 1987 in the United States Bankruptcy Court in San Diego. Former millionaire Walter Keane listed assets of only $5,702.50. Later, in January, 1989, the United States Appellate Court in the Ninth District of San Francisco canceled the $4 million against Walter Keane as excessive, though they upheld the original verdict. Margaret would have to initiate another trial to collect any damages. She declined to do so.

In bankruptcy court in San Diego, Walter's bizarre legal odyssey continued. An exasperated judge, John H. Hargrove, found Walter Keane in contempt of court on November 3, 1988 for concealing his assets. Walter blamed the contempt ruling on his Newport Beach-based attorney Herbert Niermann. Walter would later allege that Niermann was "a plant."

Judge Hargrove's contempt ruling was largely based on a deposition by one Janice Adams, a woman who came to the aid of Walter Keane after hearing of the $4 million judgment against him. Walter claimed Adams was yet another "plant," a mouth hired by the Jehovah's Witnesses to do him in: "Jan Adams gave me three blowjobs a day. Morning, noon, and night. I couldn't fuck her, you see, she didn't want to be touched. She thought I was rich, tried to open her own whorehouse in Reno. She was a woman of the night, if you get my meaning."[157] A shocked Margaret Keane later said: "Janice Adams is a very nice, respectable woman whose father bought a Keane painting. She thought Walter was in distress and lent him money. Ultimately she discovered the truth about him."[158]

The concluding chapters of *The Real Love of Walter Keane* are outraged descriptions of the libel, slander, copyright infringement, bankruptcy, and other suits that occupied him in the 1980s. He concludes with a voice from beyond, the cry of the wide-eyed waifs:

129

Today, my mind is like a parachute; it works only when it's open. Now I hear again, I see again, I feel again, I touch again. Now I love the rain, the breeze and the calm. At close of day, I sing again, strolling one step at a time along my path at the water's edge. As the sunset colors flashed in my eyes, came a whisper, "Walter, the Sunrise and Sunset are REAL. You can trust us."[159]

The contempt hearings finally came to a head on June 4, 1990, a day when Judge John Rhoades lectured Walter by saying "Mr. Keane, if you refuse to answer any questions, you will be incarcerated in the future. I will not hear any further argument as to whether you can or cannot answer the questions. I think the only way we are going to get your attention, and to refresh your memory is to put you in prison."[160]

Fearing a prison term, Walter called in his entertainer friend and avid Keane collector Wayne Newton to testify upon his behalf. Newton flew in from South Dakota and delivered an impassioned defense of Walter Keane, who, aptly enough, had often been characterized as the Wayne Newton of the art world.

I became acquainted with Walter Keane some years ago upon viewing some of his paintings in Hawaii. Those paintings inspired me. They inspired me in such a way that I then became interested in working for children's causes throughout the country, and throughout the world...The "Keane Eyes," if you will, became kind of a standard phrase that I used in describing my own daughter.

I had the pleasure of introducing Walter Keane to an audience in Las Vegas. That audience stood up with a standing ovation for him. So the effect that he has had on people throughout the world, regardless of the fact that maybe he is a little eccentric, which at times has certainly been significant. One must only look into Walter "Keane's eyes" to understand Walter Keane, and to look into those eyes is seeing the same eyes that he paints on his children.

And at a time in this country when we are dealing with four-letter words on television on a regular basis and movies full of rape and dope and child molestation and every other crime against mankind, his subjects remain exactly the same, Your Honor. They remain innocent and bewildered children. Is it possible that this day has been brought about by the wrath of an ex-wife, which for eternity some of us might be a part of, from myself all the way up to the great former president of the United States?

What you see before you, your honor, is not an arrogant man, as he has been portrayed and maybe come off that way in prior hearings. He is a giver. He has given his entire lifetime. He is financially broke. He is scared. He is vulnerable and most of his friends have passed away. The rest of us who are his friends are here today. He is not beaten because he still has his dignity and his honor. I would beg Your Honor to not

incarcerate Walter Keane, but that would be demeaning to His Honor and to Walter Keane. So I ask Your Honor, in the name of human justice and human compassion, don't incarcerate Walter Keane. Give him back to his children.[161]

In response, Margaret Keane's attorney, Nancy Perham, went on the offensive:

Margaret Keane was the artist. She is the one who suffered with the children. She is the one who painted the children. While Walter Keane was out meeting all the Hollywood stars in San Francisco, Margaret Keane was spending sixteen hours a day painting all those children... And so you talk about a spirit of the law and the spirit of justice, Mr. Newton cares for Walter Keane because of the big-eyed children. Margaret Keane painted those big-eyed children, and this man, who is supposed to be so warm and compassionate, stole that from her.

I have known Walter Keane since 1982, and when I look into his eyes I see the eyes of someone who is a liar, a fraud, and someone who is trying to hurt a person who is a wonderful person, Margaret Keane, who is being vilified here today.[162]

Shortly after the San Diego court hearing on the morning of June 4, 1990, Wayne Newton flew to North Dakota to perform. Troubled by the evidence he heard in the courtroom that day, Newton took a

jet to Honolulu several months later in order to personally apologize to Margaret Keane for his "uninformed testimony." "He didn't have to do that," Margaret later said, "He's just one of the nicest and most honorable men I have ever met."[163]

Despite the best efforts of Ms. Perham, Walter Keane escaped a prison sentence at his contempt hearing. Wayne Newton's attorney, Mark Moreno, subsequently took up Walter's case, urging him to sign an agreement that released both Walter and Margaret from pursuing further litigation against one another. Walter signed the agreement under protest. The legal show finally reached its conclusion in September 1991. The court vacated all claims by and against Walter Keane.

It was a sad turn of affairs. The way it usually works, when an alcoholic gives up drinking his or her life seems to only get better. In Walter's case, sobriety brought him nothing but bad news. Of course he'd stirred up a hornet's nest of legal troubles. His determined effort to resurrect the long-simmering dispute with Margaret, whether out of pride, cynicism or sheer delusion, was a major miscalculation. He'd played his last hand and lost. His reputation would never recover, his money was almost gone, and all he had left to lean on were his few remaining friends and his family.

He would later claim the private support of his ex-wives Barbara and Joan Marie, as well as his children Susan, Chantal, and Sascha. None was willing to testify in court. "My daughter didn't want to get involved in that," he later said. "For seven generations they've never done anything public. Not to go out to a bar, never to a public restaurant, never to a public anything. My daughter's mother is worth eight to ten million bucks. She doesn't want to get involved."[164] Neither did onetime fan Kim Novak, though she sent Walter Keane the following written testimonial early in the court battle:

Artist Walter Keane and I have been friends
for over 20 years. This note is to inform you that

133

Walter painted two pictures of me—one as a child and one of me from my Hollywood years. I also did a portrait of him which I believe he still has and enjoys. I do not wish to get into any lawsuits or publicity but wanted you to know this fact. I'd appreciate your not involving me in this as I will not be available.

Sincerely,

Kim Novak Molloy[165]

If only it were true. Margaret later revealed that Walter's celebrity portraits were actually done by her. "That was all a pose," she said. "I painted Kim Novak from a photograph and did Natalie Wood as a Big Eye kid myself."[166]

If it seemed like all was lost for Walter Keane, he would go down fighting. He still had his side of the story to tell and he continued to assert to all who would listen that he was the painter of the waifs and Margaret had shamelessly copied his artwork.

During the contempt of court proceeding in his bankruptcy trial, two San Diego-based psychiatrists, Gail Waldron and Katherine Raleigh Di Francesca, examined Walter to assess his mental health. They reported that Keane suffered from bladder incontinence and a paranoid delusional disorder consistent with heavy, long-term alcohol intake. His easygoing charm was sometimes overshadowed by suspicion and hostility. There were phantom enemies everywhere: Margaret, the Jehovah's Witnesses, an art fraud ring... If his mind was beginning to fail him, his body wasn't far behind.

"The last time I saw him was in 1990," Keane's longtime friend Bob Miller remembers. "He was living in a small, one-bedroom apartment in Carlsbad, it may have been a studio." As far as Miller was

concerned, the dispute with Margaret over the waif paintings made little difference. "I really don't care whether he painted them or not," he says. "I would have liked them just as well if they were painted by Walter or Margaret."

One of the last public sightings of Keane was in late 1993 when he put in an appearance at a Longs drugstore in La Jolla to flog copies of his vanity-published memoirs. It's unknown whether he remained sober for the final years of his life. He would live another seven years before lung and kidney disease ended his life on December 27, 2000.

His strange and eventful journey from his Nebraska boyhood to the national spotlight didn't end well, but that doesn't mean he was a failure—far from it. If Walter Keane the painter never got beyond the planning stages, the entrepreneur earned a memorable place in the history of twentieth-century American pop culture. Above all else, Keane wanted to be remembered, and for better or for worse, he won't be easily forgotten. His name will forever be inextricably tied to the waif paintings he once promoted and sold by the millions. If Keane was a flawed man, he also possessed a spark of genius. Even Margaret doesn't deny him his due. "Walter is truly a remarkable man," she once said. "But I think he missed his calling, he should have been an actor."[167]

135

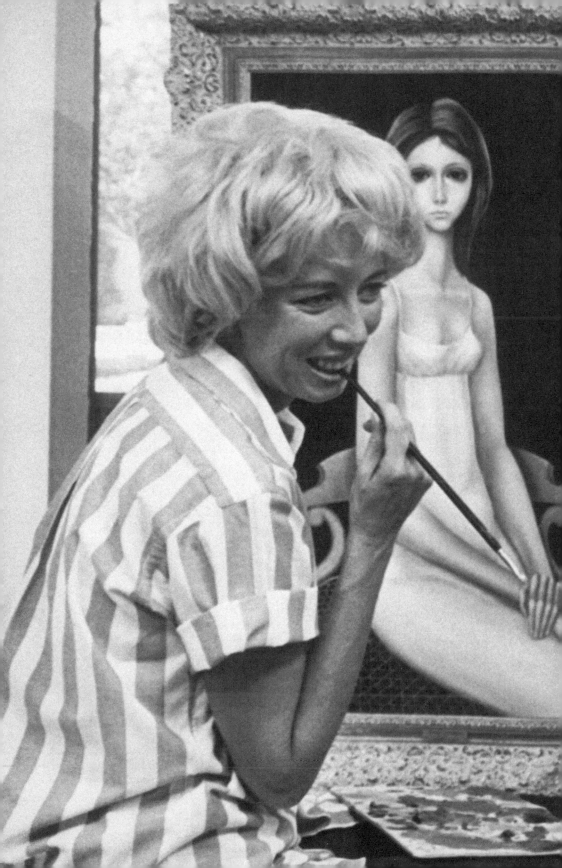

EPILOGUE
Tomorrow Forever

Margaret's 1986 courtroom victory all but broke Walter's last tenuous hold on the Big Eye paintings. Keane never gave up his doomed campaign to reassert his ownership of the waifs, but in the eyes of the jury and as far as the public was concerned, the matter was settled. Margaret was the artist who created the weepy-eyed waifs. Even if she never received a dime from her struggling ex-husband, it had all been worth it. "I didn't care about the money," the artist said after the verdict was announced. "I just wanted to establish the fact that I did the paintings."[168]

Money was never an issue. Unlike Walter, Margaret had few financial worries when the estranged couple met in court. In Hawaii, her paintings were generating regular sales and she'd long enjoyed a comfortable income from her art. The islands had been good to her; it was where she'd finally made peace with herself and found happiness. "Hawaii will always have a special place in my heart," she told a local

newspaper.[169] As much as she loved her life in Oahu, in 1991, Margaret decided it was time to return to where she'd first found success. So the sixty-four-year-old widow packed her bags and moved back to Northern California with her daughter Jane. Her timing couldn't have been better—the waifs were about to make an unlikely comeback.

Even before her resurgence, Margaret's teary-eyed children, so sentimental and deficient in irony, had been used to hilarious effect by satirists. In *Sleeper*, Woody Allen's 1973 science fiction spoof, Keane paintings are revered as masterpieces by the rich and powerful in Allen's strange twenty-first-century dystopian society. San Francisco comic artist Paul Mavrides took a swipe at the Bay Area's humorless Maoist radicals in 1979 by executing an outrageous Keane-inspired portrait of the late Chinese communist leader in the pages of *Anarchy Comics*. "Painted in oil on black velvet," read the caption, "this splendid example of true Proletarian Art combines stirring aesthetic skill with a sympathetic rendering of the late Chairman Mao's wise, yet poignant face."[170]

A few years later, *Rolling Stone* followed up with a Big Eye Nancy Reagan. Grunge Day-Glo rock poster star Frank Kozik did silk-screens of Big Eye Hitlers and Big Eye Mansons to promote Jesus Lizard shows. At around the same time, kitsch-hunters reveled in thrift-store art, outdated advertisements, obscure consumer trends, and other strange cultural relics from years past. Soon a retro craze began to gather momentum, and alongside smiley faces, Lava Lamps, and the indomitable Peter Max, Margaret's waifs became yet another guilty pleasure.

While some of Margaret's new fans were being decidedly ironic, others were deadly serious and railed against the art world's longstanding disdain for her waifs.

Jim Morton, the publisher of a zine called *Pop Void*, was one of the first to demand a critical reappraisal of Margaret's work. In the magazine's 1988 debut issue he penned an article ("Those Keane Kids")

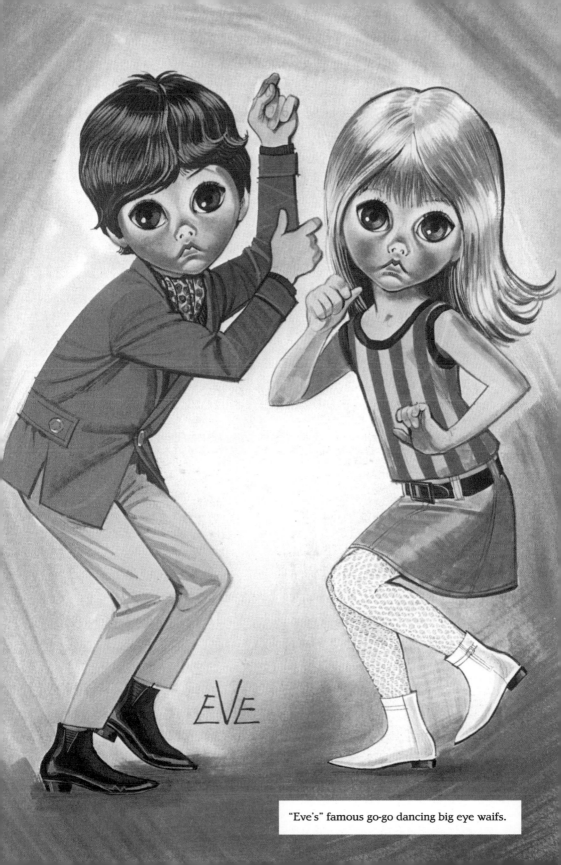

"Eve's" famous go-go dancing big eye waifs.

"How to Paint" instruction manual tells the best
way to present a crying waif.

Big Eye Keane waif contenders from the late '60s.

Pitty Puppy and Pitty Kitty made famous by "Gig".

Big Eye puppies anthropomorphized into alcoholics.

A particularly odd pedophiliac motif infests this set of big eye waifs..

This Keane-like archetypal cherub is apparently so poor
that she is forced to knit her own sweater in order
to cover her own nakedness.

Big Eye waifs step into minstrelsy and little match girl motifs.

The weepy big eye waif motif was also used
for African-American children.

Two fads in one: Big Eye Waifs meet the British Invasion.

Big Eye kitsch factor multiplies on a black velvet canvas.

Drew Friedman's Big Eye Michael Jackson is creepily and famously appropriate.

Paul Mavrides' banned Big Eye Mao art combines political satire with big eyes.

© 2013 PAUL MAVRIDES

Painted in oil on black velvet, this splendid example of true Proletarian Art combines stirring aesthetic skill with a sympathetic rendering of the late Chairman Mao's wise, yet poignant face. Surely all revolutionaries who are concerned that Art should "serve the people" will draw inspiration from this wonderful masterpiece and work hard to emulate its militance in every cultural area. All hail People's Art and roundly condemn the elitist mugwumps who inhabit the swamp of Imperialist, post-modernist, so-called "Art"!!

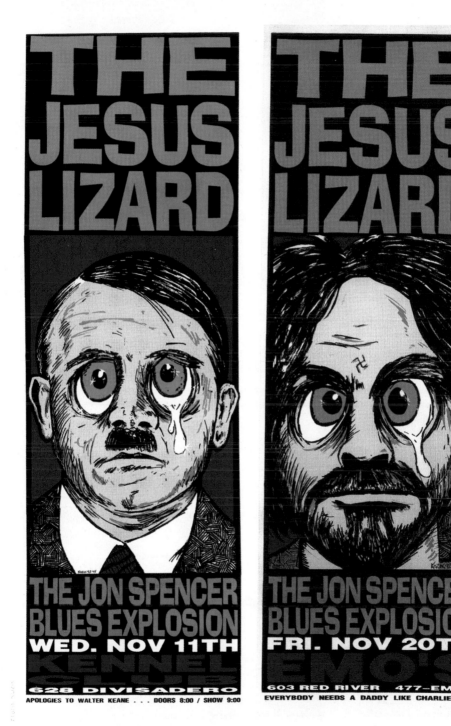

Frank Kozik's grunge-era Big Eye Hitler and Big Eye Manson rock posters.

The Keane-like teary Big Eye doll as advertised in the J.C. Penney catalogue, 1964.

4^{99}

Little Miss No-Name
Wanted: a home . . . a pair
of loving little-girl arms

LITTLE MISS NO-NAME. A pathetic little girl looking for a name, a home, a little mother to love and care for her. Her many unusual features—her straggly, rooted hair, the perpetual tear in her eye, her pleading look, her patched and ragged cotton burlap-dress—all are made to inspire hours of cre-ative, motherly play. She's 15 in. tall, just right to cuddle. Made of contoured vinyl and polyethylene plastic.
X 921-2440 A—Shpg. wt. 1 lb. 4 oz. 4.99

that called her "one of the leading modern naïve artists." Morton argued that with her waif paintings, "Margaret created something primal; something that will stay in our collective unconscious forever."[171] He also contended that the Keane kids were the true Pop Art, much more a mass phenomenon than Warhol or Lichtenstein. "Perhaps the art community will one day wake up and realize that Andy Warhol's Brillo boxes were the real fad," he observed, "and that Ms. Keane was actually the foremost practitioner of Pop Art."[172]

The *Pop Void* article was just the beginning. In a few years, the growth of the Internet would provide yet another platform for Margaret's growing Big Eye army. Websites began to spring up dedicated to her work and her many imitators. If the senior citizen artist was encouraged by this newfound interest in her paintings, she was also somewhat mystified by all the effusive praise. "I don't consider myself a master at all," she confessed to a popular woman's magazine. "The younger Pop Art types—I don't know why they suddenly discovered me."[173]

Riding this sudden wave of renewed interest, the Keane Eyes Gallery, which opened in San Francisco in 1992, was an immediate success. San Franciscans flocked to purchase her smiling, frolicking waifs, animal portraits, and somber-faced adolescents. Although the country was in the grip of a difficult recession, the newly opened gallery had no shortage of customers. Margaret also continued Walter's practice of ensuring that her artwork was affordable to everyone. There were low-cost posters and cards along with limited-edition lithographs for $2,000, and for her more well-heeled clients, original oils for $15,000 and up. A *New York Times* reporter who visited the gallery after its opening noted that "a giant painting of a cable car spilling out children, animals and balloons," listed for $185,000, had already been marked as sold.[174]

Meanwhile, Margaret ended up buying a house in Sebastopol, a small rustic town some fifty miles north of San Francisco. Known for

its lush apple orchards and proximity to Sonoma wine country, the city was fast becoming a popular location for upscale bohemian types who couldn't get enough of the scenery and old-world charm. The area, which once hosted a handful of experimental communes back in the '60s, still retained something of this bygone hippie flavor. It was the kind of place where you wouldn't have to look far to find a yoga studio, an art gallery, a vegetarian restaurant, or a vintage clothing store. Sustainable living was actively encouraged and green politics dominated local government.

Perhaps Margaret's eclectic new neighbors conjured up long-ago memories of her North Beach days. The attractive surroundings and slow-paced small-town atmosphere made it an ideal location for the aging artist. If she wasn't exactly on the same wavelength as some of her environmentally conscious fellow residents, she was not unsympathetic to their concerns. However, Margaret's Jehovah's Witness faith gave her a unique perspective on the global situation.

"I think many people are very upset and very disturbed by the things that are going on," she remarked in 1992. "The Bible shows in the Book of Revelation that God is going to bring ruin to those ruining the earth. It promises all through the Bible that the Earth will be restored to paradise conditions."[175] That wasn't all. "There will be a time," she added, "when we'll be able to live eternally on paradise Earth, which was God's purpose for Earth. We're living in what the Bible calls the Last Days. It's the Last Days of this wicked system, of Satan's system of things, where we're under condemnation of death."[176]

If her Jehovah's Witness beliefs left her feeling hopeful about the future, her new spiritual outlook also gave her a self-assurance and confidence that would have been unthinkable during the tension-filled years with Walter. And while the artist was pleasantly surprised by all the attention she was getting, she also made peace with her critics. They just didn't bother her anymore. "People either hate my paintings

or love them," she told a reporter. "There doesn't seem to be much middle ground."[177]

Even the *New York Times*, which had once given a platform to Margaret's harshest critics, buried the hatchet and published a glowing profile of her that ran in April, 1992. The article, penned by Katherine Bishop, described the artist as the "force responsible" for a "virtual renaissance of maudlin popular art."[178] Bishop recounted the artist's North Beach origins, her two-decade struggle with her husband, and the success of the Keane Eyes gallery.

A few years later, Craig McCracken, a student at the California Institute for the Arts, began developing an idea for a cartoon short he initially called *Whoopass Stew*. The story would revolve around three superpower-enhanced young girls named Blossom, Bubbles, and Buttercup—with amazingly large eyes. The name of the cartoon would later be changed to *The Powerpuff Girls*. After the initial pilot episodes were aired by the Cartoon Network in 1995 and 1996, the animated feature was picked up as a popular regular series that ran until 2005. McCracken has said that Margaret Keane's waif paintings were a major influence. "I designed them originally off of Keane paintings, in the '60s, those kids with the big, sad eyes?" he told *Frames Per Second* in 1995. "I was just doing drawings of those, and I drew these really small drawings, and they just kind of evolved into that."[179] In homage to the waif paintings, a character on the show was even named "Mrs. Keane."

McCracken isn't alone in drawing inspiration from Margaret's waif paintings. Going back to 1965, the British artist Dallas Simpson, who lived in a trailer in southern England at the time, painted dozens of doleful, big-eyed children that were reproduced and went on to sell millions of copies in the U.K. Gig modeled her work after Margaret's animal paintings and created endearing portraits of floppy-eared stray dogs and saucer-eyed cats. While most imitators merely painted big-eyed children or animals in their own individual styles, others took the

157

waif concept and added an additional twist. French artists like Genet and Michel T added oversized eyes to traditional *Gavorche* illustrations of Parisian street children. Eden and Eve blended Big Eye art with the burgeoning musical counterculture and the waifs are seen holding guitars and gyrating to music.

Margaret's modern-day adherents are often bolder and more experimental, adding elements of irony and darker themes to the traditional waifs. Japanese artist Yoshitomo Nara has been known to create sinister big-eyed children clutching weapons with their faces frozen in angry glares. Jasmine Becket-Griffith creates playful Keane-style paintings that reflect her love of fantasy and horror fiction. She often creates gothic Big Eye witches, fairies, and mermaids. Painter Mark Ryden adds a surrealistic quality to some of his Keane-inspired paintings by blending Big Eye art with classical paintings—eroding the boundaries between lowbrow and high art.

Margaret has also developed a new generation of celebrity admirers. In 1999, director Tim Burton, who as of this writing is set to direct a Margaret Keane biopic, commissioned Margaret to do a portrait of his then-fiancée Lisa Marie holding her dog Poppy. Musician Matthew Sweet and his wife Lisa became devoted fans of Margaret's work and amassed a significant collection of her paintings (along with paintings by imitators such as Gig, Igor, Ozz Franca, and others). "In the beginning we thought they were weird and cool and kind of scary," Sweet told the *New York Times*. "But as we looked at them and heard more about them, we fell in love with them."[180] The Sweets even set up a web page to celebrate their favorite Big Eye paintings.

In 2000, the Laguna Art Museum in Laguna Beach, California held a showing of Margaret's paintings and the work of artists inspired by her such as Gig, Mark Ryden, and others. The museum curator, Tyler Stallings, pondered Margaret's enduring popularity. "I'm interested in why someone like Margaret Keane achieves iconic status when Jackson Pollock, who was painting around the same time, does not,"

he explained. "I also like to look at how commercial success influences artists who initially pursue authentic self-expression, and there's some of that in Margaret Keane's crying waifs."[181] The event was sponsored by L.A. Eyeworks, which used Margaret's artwork for a series of advertisements showcasing their products.

Margaret Keane was once again a mainstream success. The year of the Laguna art exhibit, British author Wayne Hemingway made yet another argument for Margaret's artistic relevance in his *Just Above the Mantelpiece: Mass-Market Masterpieces* (Booth-Clibborn Editions, 2000). The book, which urged readers to appreciate the mass-produced art of the twentieth century, included some of Margaret's waif paintings along with works by Vladimir Tretchikoff, J.H. Lynch, and several Margaret-inspired Big Eye artists. "Certainly the painting style originated by Keane has permeated the consciousness of literally millions of people," he wrote. "If Pop Art has any link to the concept of popular art, then Keane could be as important as Warhol."[182]

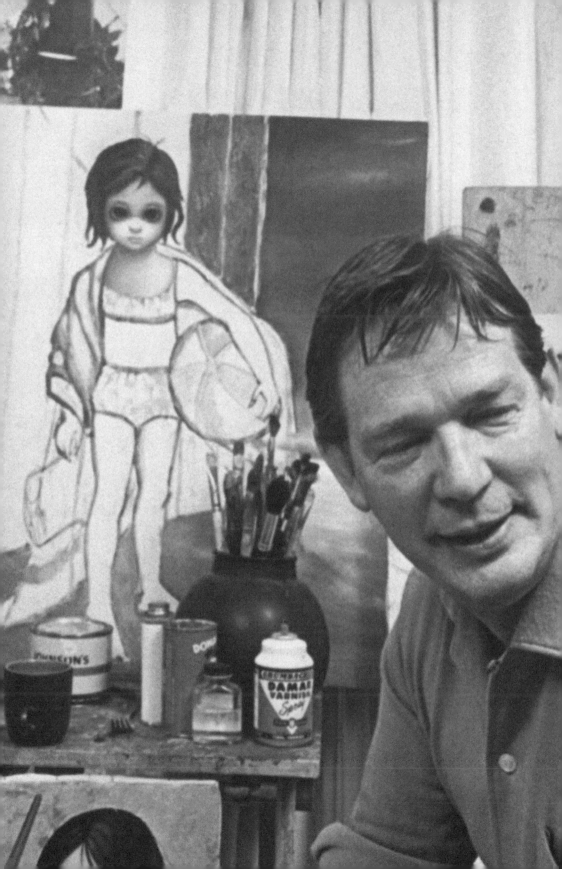

ENDNOTES

1 Fimrite, Ron. "The Keanes Split Up, but They'll Remain Partners," *San Francisco Chronicle*, March 17, 1965.

2 Howard, Jane. "The Man Who Paints Those Big Eyes: The Phenomenal Success of Walter Keane," *Life* magazine, August 27, 1965.

3 Ibid.

4 Leech, Albert. "Artist Who Gave Up Real Estate Business—and Ulcer—Doing Well," United Press International, September 11, 1957.

5 Ibid.

6 Howard, "The Man Who Paints Those Big Eyes."

7 Ibid.

8 Smith, Marlene. "Iowan Sells Public on Keane," *Waterloo Daily Courier*, November 16, 1964.

9 Howard, "The Man Who Paints Those Big Eyes."

10 Ibid.

11 Parfrey, Adam. *Cult Rapture* (Portland: Feral House, 1995), pp. 154-156.

12 Howard, "The Man Who Paints Those Big Eyes."

13 Levy, Dan. "Keane, Artist Associated with Big Eye Portraits," *San Francisco Chronicle*, January 4, 2001.

14 Hemingway, Wayne. *Just Above the Mantelpiece: Mass-Market Masterpieces* (London: Booth-Clibborn Editions Limited, 2000), p. 98.

15 Howard, "The Man Who Paints Those Big Eyes."

16 Leech, Albert. "Artist Who Gave Up Real Estate Business—and Ulcer—Doing Well," United Press International, September 11, 1957.

17 Keane, Walter. *The World of Keane: Thirty-Two Paintings and Drawings* (La Jolla: Creative Books, 1983), p. 4.

18 Ibid., p. 16.

19 Ibid., p. 35.

20 Ibid., p. 65

21 Ibid., p. 82

22 Ibid., p. 92

23 Ibid.

24 O'Donnell, Franklin. "The Eyes and the Nays of Walter Keane," *Orange County Register*, May 1, 1984.

25 Graham, Vera. "The Keane Story," *San Mateo Times*, January 11, 1964.

26 O'Donnell, "The Eyes and the Nays of Walter Keane."

27 "Class Teaches Women How to Entertain," *Oakland Tribune*, February 15, 1942.

28 Smith, Marlene. "Iowan Sells Public on Keane," *Waterloo Daily Courier*, November 16, 1964.

29 Keane, *The World of Keane*, p. 95.

30 Ibid., p. 91.

31 Graham, "The Keane Story."

32 Ibid.

33 Parfrey, Adam. *Cult Rapture* (Portland: Feral House, 1995), page 166.

34 Ibid., p. 167.

35 Keane, Walter. *The World of Keane: Thirty-Two Paintings and Drawings* (La Jolla: Creative Books, 1983), p. 98.

36 Ibid., p. 99.

37 Ibid., p. 100.

38 Ibid., p. 104.

39 Ibid.

40 Ibid.

41 Ibid., p. 105.

42 Ibid., p. 106.

43 Ibid., p. 107.

44 Keane, Margaret. "My Life As a Famous Artist," *Awake*, July 8, 1975.

45 Ibid.

46 Ibid.

47 *Eye On The Bay:* "Extraordinary People," KCBS San Francisco, aired on June 10, 2012.

48 Pauley, Gay. "Walter Keane Family Takes Paintings to New York for Special Showing," *Modesto Bee*, December 27, 1959.

49 Warner, Jennifer. *Big Eyes and All: The Unofficial Biography of Margaret Keane*, (Anaheim: Book Caps Study Guides, 2013), loc. 83 (Kindle version).

50 Parfrey *Cult Rapture*, p. 166.

51 Keane (Margaret), "My Life As a Famous Artist."

52 Keane (Walter), *The World of Keane*, p. 105.

53 Parfrey, *Cult Rapture*, p. 168.

54 Howard, Jane. "The Man Who Paints Those Big Eyes: The Phenomenal Success of Walter Keane," *Life* magazine, August 27, 1965.

55 Doss, Erika. *Twentieth-Century American Art* (USA: Oxford University Press, 2002), Loc. 1204 (Kindle Edition).

56 Hirschberg, Vera. "An Artist Who Knows What He Likes," *Pacific Stars and Stripes*, May 17, 1963.

57 Nolan, Richard. *Margaret and Walter Keane* (Tomorrow's Masters Series) (Johnson Meyers Publishers, 1960), pp. 3-4.

58 Leech, Albert. "Artist Who Gave Up Real Estate Business—and Ulcer—Doing Well," United Press International, September 11, 1957.

59 Wilcock, John. "Walter Keane, Artist: Crosses the Continent for the Show—in the Square," *Village Voice*, June 19, 1957.

60 Keane, Walter. *The World of Keane: Thirty-Two Paintings and* Drawings (La Jolla: Creative Books, 1983), p. 114.

61 Howard, "The Man Who Paints Those Big Eyes."

62 "Mrs. Keane Lectures on Art; Speech Interrupted by Rats," *Stanford Daily*, January 29, 1964.

63 Boyd, Dick. *Broadway North Beach: The Golden Years, A Saloon Keeper's Tales* (San Francisco: Cape Foundation Publications, 2006), p. 268.

64 Keane, *The World of Keane*, pp. 193–194.

65 Ibid., p. 96.

66 Bishop, Katherine. "The Waifs' Return," *New York Times*, April 19, 1992.

67 Parfrey, Adam. *Cult Rapture* (Portland: Feral House, 1995), p. 166.

68 United Press International, "Wife Challenges Artist's Acclaim," October 15, 1970.

69 Bishop, "The Waifs' Return."

70 Parfrey, *Cult Rapture*, p. 168.

71 Ibid.

72 Ibid.

73 Ibid., p. 166.

74 Ibid., p. 168.

75 United Press International, "Wife Challenges Artist's Acclaim."

76 O'Doherty, Brian. "Art: 3 Modern Displays," *New York Times*, October 26, 1961.

77 Adams, Henry. *Tom and Jack: The Intertwined Lives of Thomas Hart Benton and Jackson Pollock* (Bloomsbury Press, 2009), Loc. 5602 (Kindle Edition).

78 Callan, Mary Ann. "After Sketchy Start, Art Paid Off," *Los Angeles Times*, October 19, 1962.

79 O'Donnell, Franklin. "The Eyes and the Nays of Walter Keane," *Orange County Register*, May 1, 1984.

80 Callan, "After Sketchy Start, Art Paid Off."

81 "She Casts Cold Eye on Artist's Talent," *Los Angeles Times*, October 16, 1970.

82 Spindler, Amy M. "Style: An Eye for an Eye," *New York Times*, May 23, 1999.

83 Keane, Walter. *The World of Keane: Thirty-Two Paintings and Drawings* (La Jolla: Creative Books, 1983), pp. 125–126.

84 Ibid., p. 125.

85 Ibid., p. 126.

86 Ibid.

87 Ibid., p. 130.

88 Ibid., p. 160.

89 Ibid., p. 163.

90 Ibid., p. 165.

91 Ibid., p. 172.

92 Canaday, John. "Happy New Year: Thoughts on Critics and Certain Painters As the Season Opens," *New York Times*, September 6, 1959.

93 Canaday, John. "Art: World's Fair Pavilion Selects Theme Painting," *New York Times*, February 21, 1964.

94 Ibid.

95 Canaday, John. "Fair Backs Down: 'Tomorrow Forever,' Painting by Keane, Withdrawn from Education Hall," *New York Times*, February 27, 1964.

96 Graham, Vera. "What is Wrong with Popular Art?", *San Mateo Times*, February 29, 1964.

97 Cited in Parfrey, Adam, *Cult Rapture* (Portland: Feral House, 1995), p. 172.

98 Howard, Jane. "The Man Who Paints Those Big Eyes: The Phenomenal Success of Walter Keane," *Life* magazine, August 27, 1965.

99 Ibid.

100 Ibid.

101 Ibid.

102 Ibid.

103 Ibid.

104 Ibid.

105 Ibid.

106 Ibid.

107 "Artist Wins Legal Separation," Associated Press, March 17, 1965.

108 *Eye On The Bay:* "Extraordinary People," KCBS San Francisco, aired on June 10, 2012.

109 Parfrey, Adam. *Cult Rapture* (Portland: Feral House, 1995), p. 168.

110 *Eye On The Bay:* "Extraordinary People."

111 Parfrey, *Cult Rapture*.

112 Keane, Walter. *The World of Keane: Thirty-Two Paintings and Drawings* (La Jolla: Creative Books, 1983), p. 138.

113 Ibid., p. 140.

114 Ibid., p. 141.

115 Ibid., p. 139.

116 Ibid., p. 176.

117 Chaplin, George. *Presstime in Paradise: The Life and Times of the Honolulu Advertiser, 1856–1995* (Honolulu: University of Hawaii Press, 1998), pp. 225-226.

118 "The Lady Behind Those Keane Kids," *Life* magazine, November 20, 1970.

119 "Keane Loses Cash, Oils to Bandits," *Oakland Tribune*, May 27, 1967.

120 Keane, *The World of Keane*, p. 180.

121 *Eye On The Bay*, "Extraordinary People."

122 "Wife Challenges Artist's Acclaim," United Press International, October 15, 1970.

123 Ibid.

124 "The Lady Behind Those Keane Kids," *Life*.

125 Ibid.

126 "Eyes Have a Nay," United Press International, October 21, 1970.

127 Parfrey, *Cult Rapture*, p. 173.

128 Keane, Margaret. "My Life as a Famous Artist," *Awake!*, July 8, 1975.

129 Ibid.

130 Ibid.

131 Ibid.

132 "Margaret Keane: Artist Becomes Religious," *Hayward Daily Review*, February 24, 1974.

133 Bishop, Katherine. "The Waifs' Return," *New York Times*, April 19, 1992.

134 Keane, *The World of Keane*, p. 219.

135 O'Donnell, Franklin, "The Eyes and the Nays of Walter Keane," *Orange County Register*, May 1, 1984.

136 Keane, *The World of Keane*, p. 227.

137 Ibid.

138 Duncan, Mary. "Iconic Whaling Bar to Close," *Huffington Post*, January 2, 2013.

139 Howard, Jane. "The Man Who Paints Those Big Eyes: The Phenomenal Success of Walter Keane," *Life magazine*, August 27, 1965.

140 Keane, Walter. *The World of Keane: Thirty-Two Paintings and Drawings* (La Jolla: Creative Books, 1983), p. 230.

141 O'Donnell, Franklin. "The Eyes and the Nays of Walter Keane," *Orange County Register*, May 1, 1984.

142 Ibid.

143 Keane, *The World of Keane*, p. 252.

144 Ibid., p. 256.

145 Ibid., p. 233.

146 Parfrey, Adam. *Cult Rapture* (Portland: Feral House, 1995), p. 174.

147 O'Donnell, "The Eyes and the Nays of Walter Keane."

148 Ibid.

149 Ibid.

150 Parfrey, *Cult Rapture*, p. 174.

151 Ibid., p. 175.

152 *Margaret Keane McGuire v. Walter Keane and Gannett Co., Inc.*, No. 87-1741 (9th Cir. Jan 18, 1990).

153 Dubin, Zan. "The Eyes of Margaret Keane," *Los Angeles Times*, July 31, 2000.

154 Parfrey, *Cult Rapture*, p. 175.

155 *Keane McGuire v. Keane and Gannett Co., Inc.*

156 Kunen, James S. "Margaret Keane's Artful Case Proves That She—and Not Her Ex-Husband—Made Waifs," *People*, June 23, 1986.

157 Parfrey, *Cult Rapture*, p. 176.

158 Ibid.

159 Keane, *The World of Keane*, p. 258.

160 Parfrey, *Cult Rapture*, p. 176.

161 Ibid., pp. 176-177.

162 Ibid., p. 178.

163 Ibid.

164 Ibid., p. 179.

165 Ibid.

166 Ibid., p. 170.

167 Ibid., p. 180.

168 Iwamoto, Neal. "Keane Left Isles for California in '91," *Honolulu Star-Bulletin*, August 6, 1997.

169 Ibid.

170 Kinney, Jay. *Anarchy Comics: The Complete Collection* (Oakland: PM Press, 2013), p. 94.

171 Morton, Jim. *Pop Void*, Issue #1, November 1997.

172 Ibid.

173 Apodaca Jones, Rose. "A Keane Eye," *Women's Wear Daily*, November 2000.

174 Bishop, Katherine. "The Waifs' Return," *New York Times*, April 19, 1992.

175 Parfrey, Adam. *Cult Rapture* (Portland: Feral House, 1995), p. 169.

176 Ibid.

177 Bishop, "The Waifs' Return."

178 Ibid.

179 Townsend, Emru. "Craig McCracken on Stupid Dogs and Powerful Girls," *Frames Per Second*, Summer 1995.

180 Spindler, Amy. "Style: Footnotes," *New York Times*, May 23, 1999.

181 Dubin, Zan. "The Eyes of Margaret Keane," *Los Angeles Times*, July 31, 2000.

182 Hemingway, Wayne. *Just Above the Mantelpiece: Mass-Market Masterpieces* (London: Booth-Clibborn Editions Limited, 2000), p. 98.

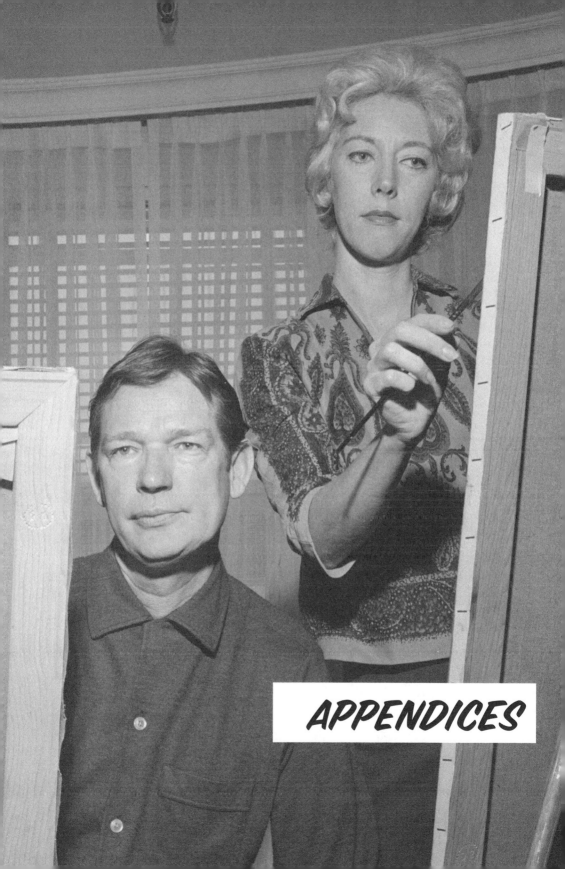

APPENDICES

EDITORIAL OFFICE: DA 2-2166; BUSINESS OFFICE: DA 3-1301

Mrs. Keane Letcures on Art; Speech Interrupted by Rats

Citing the importance of painting as a medium for expression, artist Margaret Keane addressed the Associated Women Students yesterday.

The talk interrupted several times by disturbances in the audience including the release of eight rats among the liseners.

(See Letter to the Editor, page 2.)

"Most painters," Mrs. Keane pointed out, "prefer to do their talking with a paint brush. If I had any sense I would do the same. Throughout my life words have never come easy. Only through my paintings and drawings have I been able to express my deepest feelings and thoughts."

MRS. KEANE pointed out that art is generally acknowledged to be a man's world. "Those of us women who dare enter," she stated, "do so with an awareness that the challenge and the competition is extremely keen. Yet I am certain for those of us who have trespassed, it has never been with the intention to compete, but rather to express." She expressed the view that art should be more natural to women than to men. However, it was pointed out, women have oftentimes in the past been too tied down to their daily chores to engage in the arts. Today this is no longer so true.

Mrs. Keane commented, "Today, in America, we have enough lady painters to redaub the Golden Gate Bridge twice daily and four times on Sunday. But amongst the hundred outstanding living artists, only a handful are women."

THE SPEAKER outlined briefly the careers of several outstanding woman artists. She described Mary Cassett as the first really outstanding American woman artist. This artist's sensitive drawings of mother and children have

a stack of posters advertising the newly opened Keane gallery . . ."

"EVERY WEEKEND these two poor artists made the scene up and down San Francisco hills gluing and tacking these handbills— sometimes only a block ahead of a trailing policeman who objected." The Keane posters kept disappearing, until one day the snatchers came to the gallery asking for clean editions. It was then that Walter Keane decided to charge a small price for his product. "This," Mrs. Keane stated, "was the beginning of the Keane lithograph phenomena."

Mrs. Keane moved then on to the offerings of art. "'What,' somebody once asked Gertrude Stein, 'is your attitude toward art.' She answered, "I like to look at it.' It was Duncan Phillips who said, 'The power to see beautiful is all there is worth bothering about in art.' "Perhaps," Mrs. Keane proposed, "in these two simple statements is the definition of art's most basic offering for all of us."

DISCUSSING HER WORKS, the artist came finally to that of "Dust to Dust." "As you may have noticed, the girl is not wearing a dress. Her body is the continuation of the rich rolling hills of California that nurtured her. This painting of a girl, part flesh, part earth is a way in which I have tried to extend art's message. You have to be taught there is life and there is death, otherwise how would you know this tree is alive, the other dead."

Mrs. Keane concluded. 'It (art) can, as I so devoutly believe, break through our ignorance and let us perceive tomorrow's truth . . . There must be a more positive recognition of the world we live in."

Dead Week Is

When Keane Art was the Enemy: The Stanford Rat Protest

In the course of gathering materials for this book, the authors ran across a curious news item. On January 30, 1964, the Associated Press published a short 100-word dispatch with the lurid heading "Rats for Artists." If the headline was strange, the story itself was even stranger.

The wire service reported that on January 28, a small group of disgruntled art students had released rats during a lecture by Margaret Keane at California's prestigious Stanford University. According to the article, eyewitnesses described seeing a "man in a poncho" release rodents into the crowded auditorium while a female companion "screamed catcalls" at the artist. Chaos ensued. The AP article named Michael S. Moore, a senior art student from La Cañada, CA as the chief instigator of the disturbance.

What inspired such a protest? Why rats? A cursory Internet search put us on the trail of a landscape artist and photographer named Michael Moore who had attended Stanford in the early 1960s. Was he the outspoken art student who once secreted rats in his poncho?

Moore readily admitted to his role in the rodent-themed protest. He also put us in touch with two of his fellow co-conspirators, Janet Whitchurch and Ann Miller. In the interests of historical accuracy, all three artists generously offered to share their recollections of one of the stranger campus protests of the '60s.

Were you the guy in the poncho who released the rats—and was it rats or mice (accounts seem to differ)?

MICHAEL MOORE: I was wearing the poncho, an excellent garment for concealing rats, and they WERE rats.

What was the impetus behind the protest?

JANET WHITCHURCH: One of my activities at Stanford was publicity for events at Tresidder Union which was the student union. I had made a poster for the event and was talking in the art department (small and intimate at the time) about the fact that the Associated Women Students (AWS) had invited Margaret Keane to speak as an artist. Faculty and students majoring in art were pretty appalled and we decided we had to comment on this poor choice.

MICHAEL: Outrage on the part of the art department and the people in it that the AWS would dignify someone so universally regarded as such a horrific and blatantly commercial artist with an invitation to speak. We became aware of it at the last minute so the "protest" was pretty much an ad hoc affair. There were maybe six to eight people involved in the demonstration; four or five actually had rats to release.

Why rats?

ANN MILLER: We were at an end-of-semester student art awards reception and the painters were standing around talking with Professor Lorenz Eitner, then head of the department; it was the evening before the Keane talk. This is how I saw the unfolding of events, as I had heard nothing prior to this moment: I believe Eitner brought up the fact that the Associated Women's Students committee had asked Margaret Keane *of all people* to speak on Women's Careers in Art, and had done so without consulting the art department.

He was really put out over this, and in the process of conversation

172

he jokingly suggested releasing snakes into the crowd as an expression of protest. The circle of us chimed in and someone (was that me?) said snakes might seriously have a bad effect on the audience, but some white mice might be good. Lorenz gave his blessing on this. What a twinkle in Eitner's eye! As it turned out, mice were not available, so rats were substituted.

JANET: We discussed any number of possibilities for demonstration and the rat idea won out. These plans were encouraged and abetted by the art department faculty and head of the art department (who had just been appointed the previous year).

MICHAEL: Some of us being surfers, random acts of idiocy and anarchy came easily; although there had been other more complicated actions proposed it was fairly short notice and as I had a friend in the Stanford Hospital research labs with access to rats, rats it was.

What are your memories of the demonstration?

ANN: I decided not to set any rats loose as I was the liaison writer for the *Stanford Daily* and thought it would be too awkward and I would probably have felt guilty personally. Not much of an activist at that point, or at least not a gutsy one.

I think after about ten minutes the rodents were gradually and quietly released out onto the floor and the audience started noticing and scuffling around. It took a few minutes for the people at the podium to notice and escort Margaret off the stage. Someone came up and asked the audience who was responsible. No one said anything and the campus police had arrived by that time. Then Michael stood up and said "It was my idea."

JANET: What I remember most was the overreaction of the student "monitor," Fred Nelson, who grabbed Mike and Natalie and dragged them off quite melodramatically and the fact that I was severely chastised by the Dean of Women and knew that my parents were going to hear all about it…and be upset with me for embarrassing them!

It's interesting that you sensed something kind of melancholy about Margaret as this was before she revealed that her husband was taking all the credit for her waif paintings.

MICHAEL: Not only melancholy but extreme unease at being thrust into what was obviously for her a very uncomfortable situation. During the lecture, which she read, eyes down, as if she'd never seen the material before, I could sense her extreme discomfiture, and felt our disruption to be inappropriate, but as it turned out she never noticed a thing, or so my contemporaneous description says.

What was the fallout from the protest?

MICHAEL: We were apprehended by some sort of student police force and stood trial in a sort of Student Court held in some sterile room in the Student Union; Janet and I were each represented by "counsel"; in her case renowned Gericault scholar Lorenz Eitner and in mine Nicolas Wilder, a grad student who had just switched from law to art history and went on to become a legendary L.A. art dealer in the sixties and seventies.

All (which is to say four of us, I think) were put on probation and required to write letters of apology to the mortified Margaret Keane, who became aware of the disturbance only when I punched out Fred Nelson, one of the student cops, as he grabbed my girlfriend on our way out. I had already made as public an apology as I could in the

Stanford Daily although I still felt the "art" to be horrible and its commercialization despicable. The poor woman though…arrgh! She really believed in that shit!

What were your feelings about Keane art at that time?

JANET: I thought her art was shallow, trite, ridiculous and not the best example for the University to be promoting. It seemed apparent to me that she was reaching for the lowest common denominator and $$$$$$. Like Mike, knowing how manipulated she was by Walter, I feel sorrier for her now.

MICHAEL: Keane art was ubiquitous during the time I was growing up in California and I found it to be hideous and always assumed it was made solely with cynical commercial intent. Hearing Margaret speak, it was a shock to realize that she was absolutely sincere and felt herself part of a deep if deeply maligned tradition. In retrospect, of course, the cynical commercial intent was always Walter's, but that doesn't make the work, which seemed to deliberately embody the worst aspects of beatnik figurative painting's borrowings from the worst aspects of sentimental French "modern" figuration, overlaid with overly sentimental glop, any better. Murky Modigliani posters come to mind in this regard, although murky Modigliani posters were masterpieces by comparison.

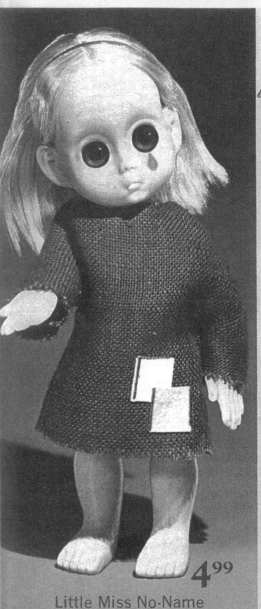

4⁹⁹

Little Miss No-Name
Wanted: a home . . . a pair of loving little-girl arms

LITTLE MISS NO-NAME. A pathetic little girl looking for a name, a home, a little mother to love and care for her. Her many unusual features—her straggly, rooted hair, the perpetual tear in her eye, her pleading look, her patched and ragged cotton burlap dress—all are made to inspire hours of creative, motherly play. She's 15 in. tall, just right to cuddle. Made of contoured vinyl and polyethylene plastic.
X 921-2440 A—Shpg. wt. 1 lb. 4 oz. 4.99

Big Eye Dolls Go Lowbrow

The Big Eye phenomenon hit the toy market in 1964 when Hasbro got in touch with Walter Keane to see if he would lend his name to a teary waif-like doll. Walter made a big fuss about not selling out his name to the toy company, but quickly enough, Hasbro put out the doll not bearing Keane's name. In fact the doll adopted a moniker backslapping Walter Keane's obstinance: "Little Miss No-Name."

In the J.C. Penney 1965 catalogue, "Little Miss No-Name" is described as being "A pathetic little girl looking for a name, a home, a little mother to love and care for her. Her many unusual features— her straggly, rooted hair, the perpetual tear in her eye, her pleading look, her patched and ragged cotton burlap dress—all are made to inspire hours of creative, motherly play." The box that held Little Miss No-Name said:

> *Little Miss No-Name*
> *The Doll with the Tear*
> *I need someone to love me*
> *I want to learn to play*
> *please take me home with you*
> *and brush my tear away*

Though Little Miss No-Name apparently failed to sell well through Hasbro, toy companies had not given up with Big Eye dolls. A "Blythe" doll was produced in 1971 by Kenner, and this ocular weirdo's huge eyes would change color by the pull of a string. And in

the late '60s to early '70s, cheap knockoff dolls called Susie Sad Eyes (later renamed Susie Slicker) were thrown out to the trade by various second-rate toy companies.

In the late '80s, when Big Eye art was largely seen as homely artifacts of a dead fad, movers and shakers in the punk lowbrow universe revived the trend once again. The images seemed bizarre, creepy, and garbage-disposal cheap—great material to source from society's aesthetic cesspool. Like mangy cats in the pound, the detested artifacts now became adored, and begged for hipster ownership.

The illustrative movement, Lowbrow, caught on big-time, particularly following Los Angeles' Museum of Contemporary Art's 1992 "Helter-Skelter" exhibition. Around this time, Long Gone John, purveyor of the Sympathy for the Record Industry label, collected a spectacular number of Little Miss No-Name dolls and peculiar commercial pop ephemera from the '60s and '70s. John's aesthetic took shape in the '80s and '90s when he employed artists like Christopher (Coop) Cooper and Mark Ryden to draw or paint advertisements and posters. The Little Miss No-Name fascination blossomed when it took a starring role in large Ryden canvases. Ryden's and John's Big Eye love for child toy and kitsch art obsessions were impressively portrayed in Greg Gibbs' full-length documentary *The Treasures of Long Gone John*.

Juxtapoz, a magazine inspired by Robert Williams' Lowbrow art conceit, reprinted a cover story written by Adam Parfrey for a 1991 issue of the *San Diego Reader*, in which Walter and Margaret Keane were both interviewed at great length, and the nasty suits and counter-suits between the couple were dug out of court records.

Lowbrow fascination for Big Eyes was revived once again in 2001 when the books *This Is Blythe* and later *Blythe Style* (2006) were published by Gina Garan, in which a Blythe doll was photographed in various settings internationally. This book in turn created a demand for new versions of Blythe dolls.

In 2013, a twentieth-anniversary tribute to an art museum show

called "Kustom Kulture" (curated by Greg Escalante) featured the work of Margaret Keane and modern-day pop artists who have done Big Eye homages—in the case of Frank Kozik, a Big Eye Hitler and a Big Eye Charles Manson.

A coffee table art book, published in 2008, called *Big Eye Art: Resurrected & Transformed* by "Blonde Blythe" features twenty-two different artists doing largely happy Margaret Keane-influenced paintings combined with Japanese anime-style Betty Boop-like figures with big eyes and round faces.

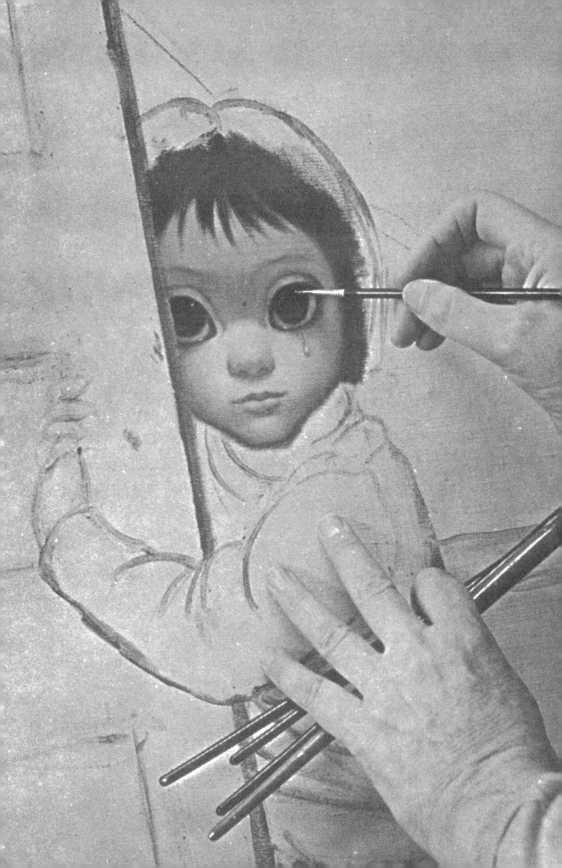

Those Keane Kids

Jim Morton

In the early '70s they were everywhere: big-eyed children staring at you from the ad pages in *Parade* magazine. Sometimes they were animals—mangy-looking cats and dogs sitting alone in grimy alleyways. Forlorn expressions and always huge eyes. It was more than a phenomenon, it was a movement. An art movement no less than Dada or Surrealism, but without the official imprimatur of the art community. This one came from the streets: ordinary people who didn't know art, but knew what they liked.

At the heart of the movement were Margaret and Walter Keane. It all started there. They created the image of the sad and lonely waif. Their paintings sold. And sold and sold. Soon there were hundreds of imitations. Thousands of them! Keane kids and their progeny clogged the thrift stores ten years after the craze. Today they are like tie-dye and polyester leisure suits: one of those moments in fashion that most people would just as soon forget they took part in. But the Keane Kids are not so easily discarded.

The Keane Kids hit the news again when Margaret Keane took her ex-husband to court, claiming that she, in fact, drew all of the children that were credited to him. To prove it, she drew one of the kids in court, challenging him to do likewise. Walter declined, saying that he hurt his hand and was unable to draw. The jury was unconvinced and awarded the suit to Mrs. Keane.

To anyone familiar with their work, there should have never been any doubt that she drew all the pictures. It is obvious: the technique,

the style, the detail. What really separates the artwork of Walter Keane from that of his wife are the backgrounds, which often appear more abstract, cruder and less well-defined than his wife's work. We suspect that Walter Keane did the backgrounds and had his wife draw the children over them (or, as one photo suggests, she drew the faces and then he finished the pictures). Often the faces of the children are so well-defined in comparison to the rest of the picture, they appear to be pasted on. The one is exception is *Survival*, a picture drawn by Walter Keane in 1945. The child in this painting is too rough and amateurishly drawn to be the work of his wife. Walter drew this one.

Lest it sound like I'm dumping on Mr. Keane, I must point out that, whatever his wife's artistic talent, it was Walter who understood the market. It was he who turned the pictures from Sunday art exhibition fare into a full-blown national phenomenon. More accurately, the Keane Kids were the result of two divergent talents coming together: the modern naïve painter and the mass-marketing expert.

Margaret Keane was a born painter. Had she never achieved any fame, it would not matter. She would still be painting. Margaret was born in 1927. At the age of ten, her mother had her take evening art classes. By the time she was in high school, the young lady was selling her drawings to other students. Eventually she moved to New York, continuing her art classes and working in a factory, hand-painting baby furniture. When the furniture factory went bankrupt, Margaret Keane made money by hand-painting ties, which were all the rage at the time.

In the early fifties, she moved to California. In San Francisco, she met and married Walter Keane, her second husband. Those were the lean years. For a while, she made money by painting portraits for tourists on the streets. But Walter had a better idea. People respect art in a gallery, he reasoned, so let's open a gallery. Scraping their money together, the duo rented a small space in North Beach to display their paintings. Soon, word got around about Margaret's fine portrait work.

182

People sought her out. Rich people. She became the "Artist of the Stars," painting such luminaries as Natalie Wood, Joan Crawford, Red Skelton, Zsa Zsa Gabor and the Jerry Lewis family.

Walter's career was quite different. Unlike his wife, Mr. Keane's interest in art was never encouraged by his family. He was to go into business, his father decided. Keane moved to Berkeley where at the age of twenty-one he began a real estate venture that, over the next three years, became a prosperous business. It also gave him ulcers. At this time, Keane decided to follow the Gauguin route and hung it all up for art.

He moved to Paris in 1945 and studied at the Beaux-Arts and the Grand Chaumière. Later, he moved to Germany where he claims he got the idea for the big-eyed children from the starving postwar urchins that filled the Berlin streets. Eventually, he moved back to San Francisco where he met and married Margaret.

Whatever his artistic pretensions, it is clear that Walter Keane's true genius was not in art, but in marketing. Small wonder that the Keanes' success is viewed more as a business venture than an artistic one. His artwork (that which can be positively attributed to him) is Sunday painter quality. But what he may lack in artistic talent, he more than makes up for in shrewd business sense. I intend this remark as a compliment yet I know Walter Keane would not take it as such. He wanted to be an artist. He abandoned everything for art. He immersed himself in the North Beach Bohemian scene. Sitting in coffeehouses till the wee hours, sipping espresso, discussing the pros and cons of surrealism, dada and abstract expressionism. Arguably, any successful artist in contemporary society must be both artist and salesman. If so, then Walter Keane was half a genius. Margaret completed the bill.

It was Walter's entrepreneurial approach to art that makes the Keane story so interesting. Walter Keane's approach to success was exactly backwards. A gallery legitimizes art, he reasoned, so I'll rent a gallery. In a more audacious move, he had printed a double-volume,

boxed set of his and his wife's paintings. Each picture was covered with a silk paper sheet and every picture was printed in full color. The set was billed as part of the "Tomorrow's Masters" series. We can only speculate as to what other artists might have been included in this series.

Once the market for their paintings was established, the Keanes had it made. They wasted no time exploring the lucrative possibilities their sorrowful children possessed. More books were produced. The couple appeared on television. Prints of their paintings were everywhere. Then came the imitations. Not as well painted, but every bit as saleable. Of these, the best were unquestionably the animals by a painter called "Gig." Pathetic-looking puppies and scrawny cats, shivering in trash-strewn alleys. Alone and forgotten. The sad animals caught on instantly and the marketing for them was relentless. You could even buy clocks with the sad creatures on them, with lights in their eyes! Today, the animals are as well remembered as the Keane paintings that inspired them.

It is not hard to understand the popularity of these paintings. One need only look at the times during which they were popular: the late '60s and early '70s. The Era of Love; Optimism's *dernier cri*. The eyes of children, bereft of innocence and filled with sorrow, but not without hope. The perfect metaphor for how we all felt. Perhaps they were maudlin. Did it matter? True, Walter Keane was marketing the paintings like an entrepreneur in a bull market, but Margaret's talent for capturing the most uncanny expressions of childhood was without peer. One need only look at the many imitations of her work and compare them to the originals. The harlequin children and Keane clones are cute, but Margaret's children are strangely haunting.

It is not surprising to anyone that the art community met the Keanes' success with scorn and derision. In the first place, their work was much too readily accepted by the general public—a big no-no in the art world. In the second place, rather than using the traditional

art channels, Walter Keane chose instead to forge his own channel. The art critics were furious! Why, they weren't even given a chance to decide they didn't like the Keane paintings. These are paintings for the kitchen (or the kitschen), not for the galleries, the critics argued. They were apparently right on this account: How else do we explain the legion of imitators that filled the ad pages of family magazines?

Whatever your personal feelings toward Margaret Keane's work, her place as one of the leading modern naïve artists cannot be denied. One need only read what she has said or written to realize that the woman knows her art. With her woebegone children, Margaret Keane created something primal, something that will stay in our collective unconscious forever. We will never be rid of those children, because we never were! Her eerie children touch everyone.

Perhaps this is partly why critics are so venomous about her work. It is an affront to rationality. The intellectual likes to stay in control of his emotions. Then along comes Margaret Keane and makes him feel sappy. The only weapon against such emotional intrusion is scorn. "It's manipulative!" the critics cry. Yes, it is—fans of the Keane paintings would be the first to admit it. In a world where we are bombarded by commercial messages every ten minutes, where the success of anything is based on how well it can be marketed, what isn't manipulation? In fifty years her work will be held up as a prime example of mid-twentieth-century naïve art. It would be fun to see art students infuriate their teachers by imitating her work. Perhaps the art community will one day wake up and realize that Andy Warhol's Brillo boxes were the real fad, and that Ms. Keane was actually the foremost practitioner of Pop Art. Until that day, keep those paintings on your walls. Hang them proudly and don't forget the children.

[This article was originally printed in the first issue of author Jim Morton's *Pop Void* magazine, published in 1987.

FERALHOUSE.COM